# HOW TO BUY PHOTOGRAPHS

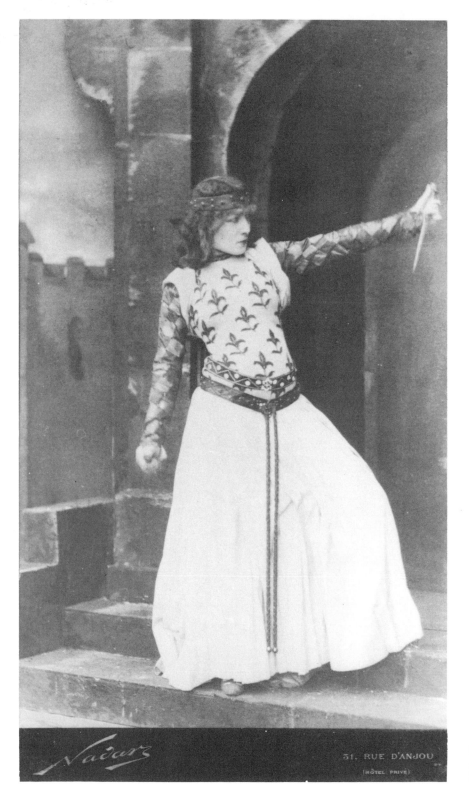

Sarah Bernhardt in *Lorenzaccio* by
Alfred de Musset. Cabinet portrait by
Nadar, Paris, c.1893.

CHRISTIE'S COLLECTORS GUIDES

# HOW TO BUY PHOTOGRAPHS

STUART BENNETT

PHAIDON · CHRISTIE'S

OXFORD

**Note**

Dollar to sterling equivalents are notoriously difficult to deal with
in a book of this kind. The figures given here are an average of a
given year's rate fluctuations, and are not intended to be any more
than approximate. The sterling equivalents used are as follows:

| | | | |
|------|--------|------|--------|
| 1974 | $2.20 | 1981 | $2.10 |
| 1975 | $1.90 | 1982 | $1.80 |
| 1976 | $1.60 | 1983 | $1.60 |
| 1977 | $1.70 | 1984 | $1.40 |
| 1978 | $1.80 | 1985 | $1.20 |
| 1979 | $2.00 | 1986 | $1.50 |
| 1980 | $2.20 | | |

The views expressed in this Christie's Collectors Guide are those
of the author. They do not necessarily reflect the views of
Christie, Manson & Woods Ltd.

Phaidon Press Limited, Littlegate House, St Ebbe's Street,
Oxford OX1 1SQ

First published 1987
© Phaidon · Christie's Limited 1987

British Library Cataloguing in Publication Data
Bennett, Stuart, *1950-*
    How to buy photographs.
    1. Photographs—Collectors and collecting
    I. Title
    770'.75   TR6.5

    ISBN 0-7148-8036-1

Designed by Roger Lightfoot

Typeset in Apollo by Hourds Typographica, Stafford

Printed in Britain by Butler and Tanner Ltd., Frome, Somerset

# CONTENTS

FOR MY MOTHER AND FATHER

# Introduction

While the older and more traditional areas of collecting—paintings, porcelain, silver and the like—are necessarily the preserve of the fairly wealthy, photography offers vast scope even for a collector of quite limited means. This is not to say that all, or even most photographs are inexpensive; rare and beautiful ones command enormous prices almost daily at auction and in dealers' showrooms. But well short of such rarities lies a huge range of moderately priced items, many of them things of beauty in themselves but also endowed with a quality shared by no other kind of collectable: the visible recording of a real time and place. Even the finest painting is a result of selection, elimination and emphasis; a photograph, however great its artistry, also says 'This is exactly how it was'.

Collecting photographs is a fascinating and deeply rewarding pursuit. Like all such it has its share of difficulties, of traps and pitfalls for the eager novice. In this book I try to offer guidance past some of the more obvious of these and to hint also at some of the more obvious pleasures. Though in the final analysis it is all up to the style and taste of the individual collector, I shall repeatedly harp on certain strings as far as specific collectors' 'points' are concerned:

1 Buy 'vintage' prints whenever possible, 'vintage' in this context meaning prints made at or around the same time as the production of the negative.

2 Look for signs of the photographer's own hand having been involved in producing the print. This is not always possible with early nineteenth century photographs, such as those by Fox Talbot and other early practitioners, but as the century progressed many photographers began to sign or stamp their prints, and this signature or studio stamp, especially on twentieth century photographs, is the buyer's best guarantee of authenticity.

3 Avoid photographs in poor condition unless you are reasonably certain that no other print exists or is likely ever to appear for sale. Tears, creases, stains, and foxing are anathema to purist collectors. Overt signs of restoration can be even worse, arousing indefinable and inconsolable suspicions on the part of subsequent purchasers.

4 Above all buy photographs that fascinate and haunt you, even if this often means your buying one great photograph that you can barely afford rather than three you may come to regret.

This book does not pretend to offer anything like a history of the photographic medium. One chapter—the second—deals with the development of photography *collecting*, and may provide some insight as to why the market for photographs is as difficult for the collector as it sometimes appears to be. Other chapters offer more specific advice on the kinds of material available for forming a collection and the paths a collector might take; approaches to buying and selling and considerations of photography as an investment; special factors involved in collecting the work of modern photographers; faked photographs and other collectors' pitfalls; and how to look after a photography collection. There is a substantial appendix of technical terms, chronologically ordered and with historical notes; it is based on my own experience and includes only those terms which I believe collectors are most likely to encounter in the marketplace. Finally there is a brief directory of possible sources of supply and a list of suggestions for further reading. Needless to say, these last two appendices are by no means comprehensive, but they do include most of the people and books I have found helpful over the years.

This book will certainly not tell you everything you need to know about collecting photographs, any more than a book about cars and motoring will teach you how to drive. But both could be said to have similar intentions: to give you an idea of what to look for in the new and secondhand market, to develop your own style, to help you to avoid dangerous manoeuvres, and perhaps ultimately to help you get wherever you want to go.

This book would never have been written without the encouragement and help of my wife, Kate Carlson. Sam Wagstaff, Gerard Lèvy and Harry Lunn all gave generously of their time and patience in speaking to my small, intractable tape recorder. Eleanor Antin, Bill Arnold, Zelda Cheatle, Sue Davies, Fay Godwin, Christine and Charles Hadley, Mark Haworth-Booth, Katy Homans, Helen Levitt, Mari Mahr, Mary-Anne Morris, Howard Read, Peter Ruting, Erich Sommer, Sean Thackrey, John Varriano, Wendy Watson, Steve White and Taki Wise were unhesitating in offering me both words of wisdom and/or illustrations for this book. Special homage is due to both of the great rival auctioneers, Christie's and Sotheby's, and especially to David Allison and Lindsey Stewart of Christie's South Kensington, Philippe Garner and Nicola Redway of Sotheby's London, Claudia Gropper of Christie's East and Beth Gates-Warren of Sotheby's New York, who unsparingly ransacked their photography archives for me; many of the illustrations published here can otherwise be seen only in out-of-print auction catalogues.

# 1. Rarity, Technique and Taste in Photography Collecting

An all-too-often seen type of 1860s photograph, with pale and washed-out tonalities, and the mount trimmed where the photograph was once framed. This photograph is Julia Margaret Cameron's portrait of Thomas Carlyle; compare its pallor with the rich and lustrous tones of the same photographer's 'Iago' on page 10.

One fact of the photography market is that, as of the mid-1980s, the number of major collectors and institutions could be numbered in dozens, and not many dozens at that. Yet for some time demand for the best prints by significant photographers has exceeded the supply.

If this seems puzzling the solution is straightforward. There was little reason for photographers, other than commercial studios, to produce multiple prints during the first century or so of the medium's existence. Even where significant non-commercial print runs are known in the nineteenth and early twentieth centuries—by 'significant' I mean perhaps ten examples, rarely more—the quality of the individual prints varies so much, especially during the medium's first few decades, that a whole new set of collector's criteria based on condition have come to be applied.

This chapter attempts first to establish a basis on which the collector can judge the probable rarity of an individual photograph and relate rarity to condition, and second to offer a guide to the reader in defining his or her own aesthetic view of the medium. These three elements, rarity, condition and taste, are inextricably linked in the marketplace, since it is the photographs most people perceive as great that command the most attention and, consequently, become the most sought-after.

Comparing prints made from the same negative of Julia Margaret Cameron's portraits or Roger Fenton's Crimean War scenes can be a disheartening exercise. More often than not these albumen prints have a pallid, washed-out look, the result of either poor printing or later over-exposure to light. Even with these and other well-known early photographers the number of really desirable examples of a particular image is unlikely to number more than a handful. And, since the number of major collectors can be numbered in dozens, Adam Smith's classic economic principle—'the invisible hand of supply and demand'—produces rising, in some cases skyrocketing, prices.

Collectors now tend to look back rather wistfully at the 1970s prices for great photographs. At the time, of course, many of those prices set records: the £52,000 ($114,400) bid by Sam Wagstaff at Sotheby's in 1974 for the presentation album of Julia Margaret Cameron photographs,

Julia Margaret Cameron. 'Iago. Study from an Italian', albumen print, c.1865. From an album of 94 photographs presented to Sir J.F.W. Herschel in 1864, and 'completed' by the photographer in 1867. The album sold at Sotheby's Belgravia in 1974 for £52,000 ($114,400), and after a public appeal for funds was secured for the National Portrait Gallery in London.

given by the photographer to the astronomer Sir John Herschel, remained the highest price paid for any photographic lot at auction for years. But I have little doubt that if one particular portrait from that album, the one that Mrs Cameron called *Iago* and of which no other print is known, were to turn up at auction tomorrow its price would very likely exceed the bid for the entire album of ninety-four photographs in 1974. Similarly Jabez Hogg's splendid daguerreotype self-portrait showing him taking a photograph in Beard's commercial daguerreotype studio, *circa* 1842, set a short-lived auction record for a single photograph in 1977: £4,800 ($8,160). It seems an almost pathetically small sum compared with the $36,000 (£20,000) (plus 10 per cent buyer's premium) paid for Albert Southworth's magnificent daguerreotype self-portrait at Christie's New York in 1982. All these prices, of course, reflect the recognition of both aesthetic quality and rarity of the photographs. For daguerreotypes, ambrotypes and tintypes, the question of rarity is simply answered: each is by its very nature unique, since the 'negative' inserted into the camera was developed into the finished positive, and no duplicates could be made.

For any paper photograph of the nineteenth and early twentieth centuries perhaps the most important criterion to apply in trying to establish rarity is publication. Publication of paper photographs as defined in this chapter may take several forms. The most straightforward is ordinary book publication, where original photographs were pasted onto sheets of paper and bound into books along with text. The earliest well-known example of this type of book production is Fox Talbot's *Pencil of Nature*, 1844, where Talbot's salt prints ('calotypes') were the mounted photographs, and his text was concerned with the various possible uses of the new medium. Later in the nineteenth century photogravure processes were invented and used in the production of books, portfolios and journals, most notably some of P.H. Emerson's Norfolk books, Edward Curtis' *North American Indian*, and Stieglitz' *Camera Work*. Some unpublished photogravures, including works by the Photo-Secessionist Alvin Langdon Coburn, exist, but as a rule photogravures may be taken as published unless there is strong evidence to the contrary.

Some photographs mounted in books are of extraordinary beauty—P.H. Emerson's platinum prints from *Life and Landscape on the Norfolk Broads*, produced before his adoption of photogravure techniques, spring immediately to mind—and the quality of many of these prints is high, even in books published as early as the noted French printer Blanquart-Evrard's works of the 1850s, or Alexander Gardner and George Barnard's chronicles of the American Civil War, produced in the 1860s. By the end of the nineteenth century, however, most book publication, apart from a few self-consciously 'fine art' productions, stopped involving either mounted photographs or photogravures.

Useful illustrations of the 'publication' principle may be cited from the very earliest days of positive-negative photography, as for example a comparison of the availability of the work of Hippolyte Bayard with that of Fox Talbot. Bayard, though perhaps the first photographer ever to

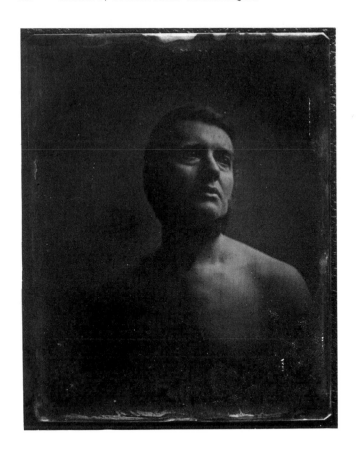

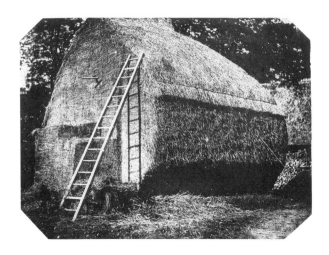

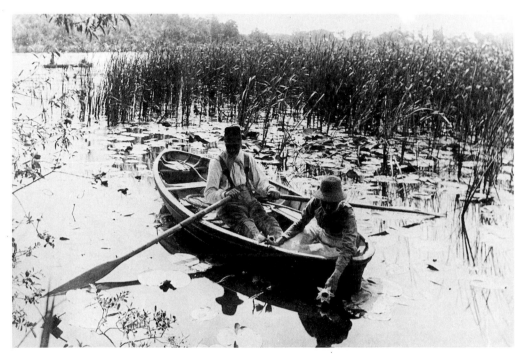

*Opposite left* Albert Sands Southworth. Self-portrait, half-plate daguerreotype, c.1848. The extraordinary price of $36,000 (£20,000) was reached in spite of the condition of the daguerreotype being less than perfect, with some scratches and fingermarks on the image surface.

*Opposite right*
William Henry Fox Talbot. 'The Haystack', salt print, from *The Pencil of Nature*, 1844. An unusually fine print, with the rich tonalities highly prized by collectors.

Peter Henry Emerson. 'Gathering Water-Lilies', platinum print, from *Life and Landscape on the Norfolk Broads*, 1886. I have a soft spot for this work, since its first appearance at a photography auction was in my first specialized sale at Christie's South Kensington in June 1976. The book put Christie's on the map by fetching a record £12,000 ($19,200). This single print appeared at Christie's East, New York, in May 1980, and fetched $3,200 (£1,455).

mount an exhibition of his photographs, never tried to 'market' them; the few surviving multiples were probably produced for presentation to friends. Talbot, on the other hand, mass-produced certain images for his books *The Pencil of Nature* and *Sun Pictures in Scotland*, of which perhaps a hundred or so copies were produced in 1844 and 1845. In 1846 Talbot launched what may have been the largest photographic print run of the century: some 6,000 calotypes were produced at his Reading establishment for insertion in a single issue of the *Art-Union*. Many of these mass-produced prints survive but most are in poor condition. Talbot's unpublished images, though not so rare as Bayard's, are nevertheless unlikely to be found in multiples of more than a half-dozen, though perhaps in a few cases Talbot may have distributed a greater number as part of his determined attempt to proselytize his new process.

This comparison, going back as far as the 1840s, may serve as a touchstone for the first century of photography. Published books containing a substantial number of plates, whether mounted original photographs or photogravures, have since the early 1970s been systematically disbound and the constituent photographic plates offered for sale as original works of art. There is nothing unusual about this: books with etchings and coloured engravings have been similarly disbound for the collectors' market for centuries. In most photographically illustrated books there tend to be a few images generally accepted as the photographer's finest—Talbot's *Haystack*, for example, or P.H. Emerson's *Gathering Water-Lilies*, or some of the individual plates from Blanquart-Evrard's impressive series of publications documenting French architecture and the discoveries of French travellers abroad. These outstanding images always command the highest prices when offered for sale, and the remainder of the plates in the books tend either to sell for lower prices or to remain in the marketplace, creating the impression that the work of the photographers involved is of little rarity.

Similarly nineteenth century photographs not published in book form but marketed publicly through art galleries or retail print shops for tourists can be as easy to come by as photographs from books. Roger Fenton's photographs of the Crimean War, printed for and sold by the art dealers Agnew's, and some of the more popular Julia Margaret Cameron photographs, e.g. her study of the poet Alfred Tennyson as *The Dirty Monk* sold by the art dealers Colnaghi's, survive in comparatively large numbers. Other Fenton photographs, notably the *tableaux vivants* which came to light at Christie's in 1977, seem known only in single examples, as does Mrs Cameron's great *Iago* portrait, mentioned earlier.

Topographical photographs of the nineteenth century were also widely marketed and are quite common, but there are exceptions. Desiré Charnay and John Thomson's published books of views taken in such far-flung places as South America and Cambodia are far rarer than the at-first-sight unpublished albums of views of such tourist spots as Italy and the Middle East. For the collector to put all of this into perspective it is necessary only to realize that Charnay and Thomson's books were produced in small numbers for a highly specialized audience, whereas the tourist albums were compiled by their publishers on demand for grow-

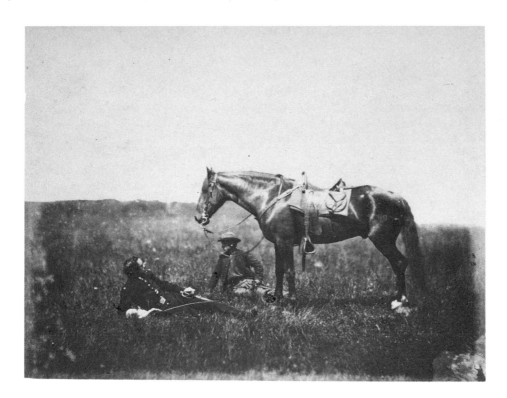

For me this is the most poignant of American Civil War photographs. It was taken by Timothy O'Sullivan, and published in Alexander Gardner's *Incidents of the War,* 1866.

Hippolyte Bayard. Study of two items of statuary, salt print, 1839, one of the earliest photographs ever sold at auction. The number of Fox Talbot photographs offered at auction in England and America during the 1970s and 1980s can be counted in dozens; this seems to be the only example of Bayard's work to appear at auction during the same period. It fetched £6,500 ($9,100) at Sotheby's London in 1984.

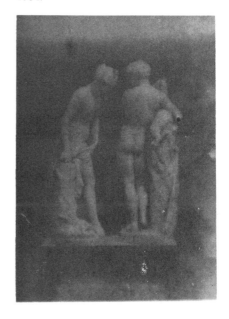

ing hordes of tourists at beauty spots as various as Niagara Falls and the Himalayas, or in cities such as Tokyo and Rome. These albums, and the prints in them, became more readily available as the nineteenth century progressed, so that 1850s albums are now quite rare while 1890s ones are extremely common. As with Fentons and Camerons, many early published topographical prints, such as Macpherson's and Alinari's in Italy and the Bisson Frères' in France, bear blind-stamps in the mounts and will often have a series number or a photographer's signature, or both, in the negative.

The 'publication' principle as a guide to rarity may equally be applied to early British and American photographers like Lewis Carroll, William Lake Price, H.P. Robinson, O.G. Rejlander, Mathew Brady and Alexander Gardner, to other early continental practitioners and to fine art photography on through the period of the Linked Ring and the Photo-Secession, up to the time of such artists as Man Ray, André Kertesz, and Ansel Adams, to name only a few. The only distinction that need be made between the earlier and later photographers mentioned here is that the kind of rarity I am asserting for most photographic prints before about 1960 will apply only in the case of 'vintage' prints by the modern masters, that is prints produced contemporaneously with their negatives. Appreciation of fine original condition has come to play an increasing role in the market for published photographs, as has growing awareness of the aesthetic impact and comparative rarity of large-format (11 × 14 in. or larger) touristic views of the nineteenth century, such as

*Below* One of the first and greatest of books published with Blanquart-Evrard photographs: Maxime Du Camp's *Egypte, Nubie, Palestine et Syrie,* 1852, with 125 photographs, this one showing Du Camp's friend Gustave Flaubert sitting on top of the Colossus at Ibsamboul. The complete work first appeared at auction at Christie's South Kensington in 1986 and fetched £30,000 ($45,000).

*Below right* Roger Fenton's favourite 'nubian' model, in a 'tableau-vivant' which I titled 'The Water-Carrier' in 1978. Another study from the same session, featuring the same model and water-vessel, was published with Fenton's printed credit, enabling this extraordinary series of studio studies to be conclusively identified as Fenton's work. Many of the prints appear to be unique. They were sold at Christie's South Kensington between 1978 and 1980.

those by Frith, Adolphe Braun, the Bisson Frères and others. These large-format views cost their original purchasers considerably more than smaller versions and are correspondingly rarer; modern purchasers pay premiums accordingly. A Bisson view, for example, of the snow-capped Alps can be stunning in large format, its impact diminishing substantially as its size is reduced. Furthermore, at a time when photographic enlargement did not yet exist the craftsmanship required to produce a successful large-format photograph was considerable, and more likely to engage the attention of the master-photographer than the small-format prints for albums, which could be left to assistants. A sort of parallel may be drawn with the industry producing photographs of cinema stars that grew up in Hollywood during the 1920s. Many of these photographs have an undeniable impact, but most collectors will always want, if they want Hollywood photographs at all, the prints made by the photographer himself, preferably mounted and signed, and therefore representing the photographer's own specific intentions for the image rather than the mass-produced 'glossies' sent out by the studios. So it is, I believe, with nineteenth-century touristic views, and as connoisseurship in the field evolves perhaps more and more collectors will begin making the kind of expert distinctions drawn by such curators as Pierre Apraxine, who in 1978 acquired for the Gilman Collection an apparently unique set of Maxime du Camp's salt prints which had served as proofs

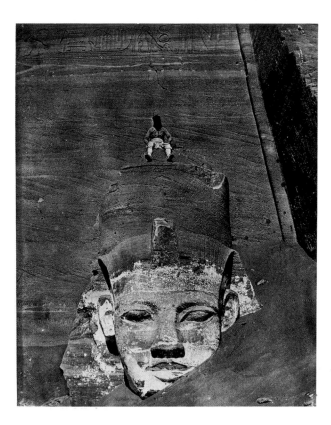

for the publication *Egypte, Nubie, Palestine et Syrie*, with 54 additional images not present in the published edition, issued by Blanquart-Evrard in 1852. 'The range of coloration of the prints, passing from earthy brown to chalky white, is quite unlike the neutral grays of the Blanquart-Evrard edition, and inspires an appreciation for the richness of color to be found in early photographs.[1]

So far the advice I have offered collectors in this 'mainstream' of photography has been technical, concerned with editions and with the physical qualities of photographs. All of this is, I think, important background information, but it does not really resolve the aesthetic issues involved in establishing the desirability of certain prints over others.

Every great photographer has produced dull photographs. As Cartier-Bresson once said, 'You have to milk a lot of cows to get a little cheese.' In 1978 I described some of Roger Fenton's tableaux vivants as 'merely self-indulgent whimsies, as when Fenton poses himself with a hookah in front of a dancing girl'[2] but this same series included a photograph which must be one of the transcendently great photographs of the century, an odalisque which in its striking and unforgettable simplicity of composition seems to me a logical counterpart to the concentrated perspective of the best of Fenton's architectural studies. Some of Mrs Cameron's portraits are flawed technically, as when her soft focus fades into a blur, or by defects in her albumen glass negatives. Others simply feature uninteresting faces, a problem which later photographers like Gertrude Käsebier and Edward Weston, who worked as commercial por-

Opposite  Lewis Carroll (C. L. Dodgson). Alice Liddell as a Beggar-Girl, albumen print, *c*.1859. This magnificent print is the only one from this negative I have ever seen for sale; it fetched £5,000 ($8,500) at Sotheby's London in 1977.

'The Spaghetti-Eaters', albumen print, *c*.1875. One of the more intriguing of the tourist photographs sold in large quantities from the mid-1850s onwards. This one is in a Massachusetts private collection, and cost its owners $75 (£50).

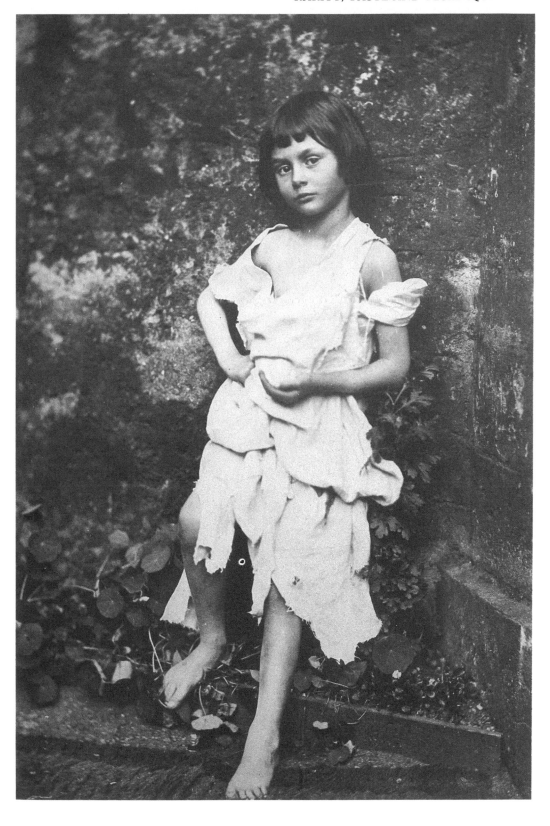

traitists, were similarly unable to overcome. Several of Emerson's *Life and Landscape on the Norfolk Broads* platinum prints are dominated by the reeds of the Norfolk marshes: the eye and the attention soon wander, only to be arrested again by the striking compositional effect of *Gathering Water-Lilies* or *Pond in Winter* from the same book.

Developing your own taste in collecting is, of course, the essence of forming a collection. Sam Wagstaff has said: 'Some people like to bet on the other guy—the dealer. I enjoy saying "To hell with you and you and you. This is what *I* think is good." It takes a certain amount of—I don't know whether arrogance is the right word—it takes a certain amount of self-approval to do that. But that's when it's fun.' One of the pleasures of producing this book is that I believe it can legitimately argue that photography is the only collecting field in the visual arts where so many aesthetic decisions are still left to the individual viewer. Paintings, watercolours, prints, maps, all have their hierarchies far more fixed, and moreover can never compete with the sheer number and variety of available photographic prints. The twofold challenge for the collector of photography is to find his or her own point of view and then find the confidence to act on it in the marketplace.

Unlike many of my contemporaries I am largely unmoved by Atget, but when he does move me I feel that his art has recreated the city of Paris. In Atget's work people are rarely seen, as if Paris were a ghost-town, or as if Atget photographed on the fifth day of creation, before God had made man. Most of the time, though, I get no *frisson* of excitement from this photographer, only the kind of cool appreciation that comes from looking at perfection. Before Hill and Adamson's photographs I tend to feel a little intimidated, perhaps because of the almost Rembrandtian complexity and tonal contrast of their best work and the weight of Hill's compositional effects. I feel much less in awe and more at home with the wonderful literary 'kitsch' of studies like Lake Price's *Don Quixote in his Study* and H.P. Robinson's *Little Red Riding Hood*: Robinson's *Fading Away*, however, much loved by the Queen and Prince Albert, contains too much high Victorian sentiment for my taste. Some of O.G. Rejlander's less-known work, especially the direct intensity of his portrait of Mr and Miss Constable, has for me an unfailing and powerful attraction. On Julia Margaret Cameron I could wax eloquent for pages; better, perhaps, to quote J.B. Priestley's response to one of her portraits of a Victorian beauty, which in my opinion is one of the best descriptions of the power of photography ever written:

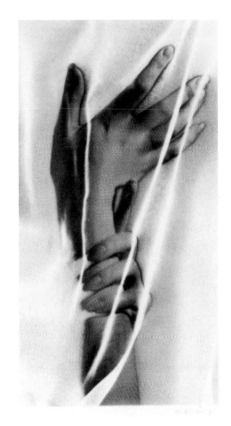

Man Ray. Study of Hands behind a Veil, solarized silver print, 1930s, signed on the mount. In 1981 this print brought £1,800 ($3,780) at a Sotheby's London auction; exactly ten years earlier, in the same saleroom, two Man Ray 'Rayographs' fetched £110 ($264) each.

It would not be the same if this were not a photograph but a painting or drawing, some other man's vision. That would be art, but this, however artfully the sitter has been posed and the camera handled, is an objective record. This is how she was, on such a day, and not how she sang in some man's brain. But though a photograph indeed, this is an old, old photograph, taken a long lifetime ago, and everybody who first admired it is dead and gone. It is a legacy too from some tiny golden age of photography, some pure and massive Old Kingdom of lens and plate, of autumnal sunlight and sepia shadows.[3]

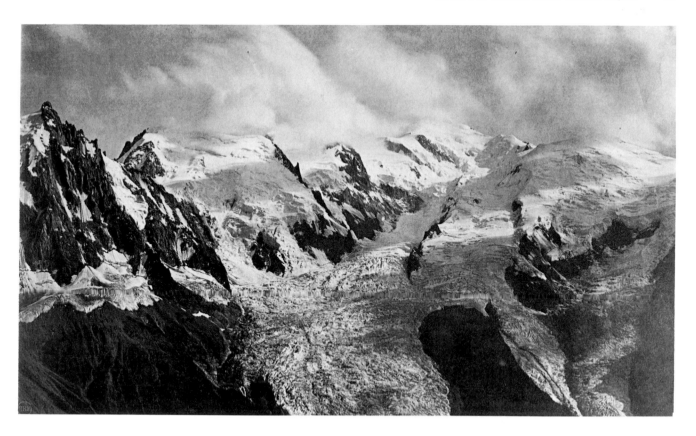

This particularly grand large-format Bisson Frères study, 'Le Mont Blanc avec Nuage', mounted with the photographers' facsimile signature, fetched £650 ($1,170) at Sotheby's London in 1982.

Mrs Cameron also summarized her own achievement with an impressive economy of language: 'I longed to arrest all the beauty that came before me, and at length the longing has been satisfied.'[4]

Nadar's portraits were taken around the same time as Mrs Cameron's, but he brought an entirely different philosophy to his subjects. He spoke of 'the moral grasp of the subject—that instant understanding which puts you in touch with the model, helps you to sum him up, guides you to his habits, his ideas and his character and enables you to produce, not an indifferent reproduction, a matter of routine or accident ... but a really convincing and sympathetic likeness, an intimate portrait.'[5]

The American Mathew Brady's best work has far more in common with Nadar's ideal than with Mrs Cameron's. There is an impressive gravity to his 1850s portrait of the soon-to-be Confederate General A.P. Hill that entirely transcends the more usually seen mechanical quality of commercial American portraiture of the period. To my eye it has stylistic links with the exquisite perfection of Edward Steichen's portrait of Princess Yusupov, taken seventy years later.

Fox Talbot's gifts lay elsewhere than portraiture. His *The Haystack*, described by Ian Jeffrey as 'nothing more than a celebration of sheer presence,'[6] conveys to me more than any other Talbot photograph his utter fascination with the near-magical quality of the new process. There is a similar celebration of presence, albeit of a more exacting kind, in

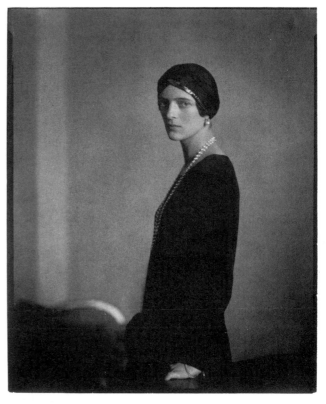

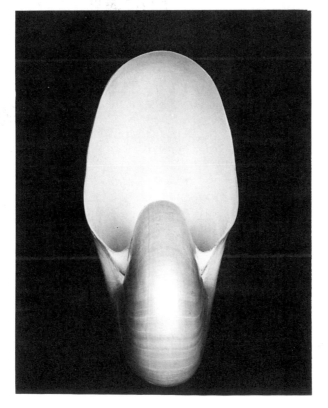

*Above left*  Mathew Brady.
Ambrose Powell Hill, salt print from a
glass negative, *c.*1858. Courtesy of the
Gilman Collection, New York.

*Above right*  Edward Steichen.
Princess Yusupov, silver print, 1924.
One of Steichen's simplest yet most
penetrating portraits. The Princess in
this photograph is described by
Pierre Apraxine as displaying an 'air of
melancholy resignation'. She had reason
to be melancholy: in 1916 her beauty
was used as bait to lure Rasputin to his
death. Her husband, Prince Felix
Yusupov, struck the fatal blow.
Courtesy of the Gilman Collection, New
York.

*Left*  Edward Weston. Nautilus, silver
print, 1927, sold at Christie's East in
1981 for $26,000 (£11,818).

Burmese Courtesan with Cigar, albumen print, circa 1880. This photograph fairly leapt from the page of an otherwise entirely undistinguished travel album consigned to Christie's South Kensington in 1977. The album brought £110 ($187).

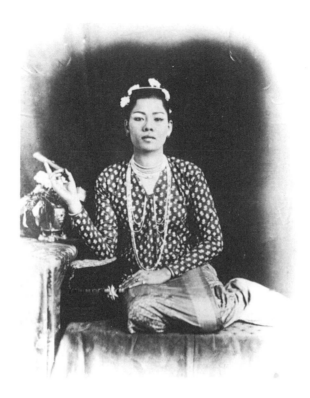

some of Talbot's photogenic drawings, which were made without the use of a camera (Man Ray adopted the process for his *Rayographs* nearly a century later), and in Edward Weston's *Nautilus*, where the camera has been used with the precision of a surgeon's scalpel. All of these studies—perhaps I should say all great photographs—seem to show the photographer revelling in making pictures, as Fox Talbot put it in 1844, 'impressed by the agency of Light alone.'

Collecting the work of acknowledged masters of photography can offer an immensely rewarding challenge, but in some ways an even greater challenge lies in the quest for exotic images by lesser-known or even anonymous photographers. Eschewing the work of named photographers can open up a whole new visual world, uncluttered by any external associations, where only the image itself counts. Consider, for example, this anonymous 1880s portrait of a Burmese courtesan, which for its sheer impact I would rank with any of the productions of the photographic 'greats'. Or look at the deliciously art deco quality of the 'Sphinx' by the little-regarded 1920s photographer E.O. Hoppé. Better yet, get hold of a copy of Sam Wagstaff's *A Book of Photographs* and consider the many photographs and photographers there who remained unsung until Mr Wagstaff raised his voice. Consider also the introduction to Wagstaff's book, which I quote here in full: 'This book is about pleasure, the pleasure of looking and the pleasure of seeing, like watching people dancing through an open window. They seem a little mad at first, until you realize they hear the song you are watching.'[7] I hope that

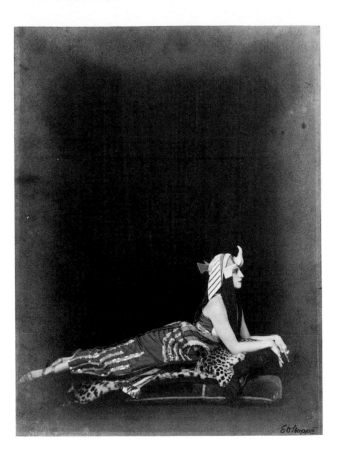

E.O. Hoppé. One of several studies of a ballet production of the 1920s.

some of these photographs may whet your collector's appetite. If so, then remember that taste, your own taste, must be the final arbiter in forming a collection. Gerard Lèvy compares a collection with a woman: 'Are you ready to give? Because the more you give to her the more she sends back. If you treat your photographs as slaves—always buying and selling— you are bound to lose. In collecting, everything done without love is lost, because there is no spark, and when there is no spark there is no life.'

My remaining chapters offer a brief historical survey of collectors and collecting, information about specific collecting areas, how and where to buy and sell photographs and the pitfalls involved therein, and technical information about photographic processes. All of this is aimed at saving collectors from the mistakes that come of inexperience, but neither I nor anyone else can save collectors from mistakes made out of greed or bad judgment. If a collector's approach to the medium is genuine—if he or she looks hard and buys the very best that can be found— mistakes will be few and far between. Nor will individual purchases ever truly be over-priced. Someday, as Lèvy says, there will always be someone 'madder than you and richer than you who will buy your whole collection. And so you will have two pleasures: collecting them and selling them. And then you can begin all over again...'

# 2. Collectors and Collecting: a Survey

R.H. Cheney. 'Reading Room. British Museum', albumen print from a paper negative, mid-1850s. R.H. Cheney was the uncle of the Alfred Capel-Cure whose photography collecting is mentioned in Chapter 2. Cheney's considerable photographic output seems to have survived only in the prints preserved in the Capel-Cure family albums.

Though the modern art market for photography is a phenomenon of the 1970s, collecting photographs is far from new. Prince Albert was an active collector from at least the early 1850s, purchasing among other things some daguerreotype views from Claudet's gallery which had been copied for the 1840 French publication *Excursions Daguerriennes*. Mark Haworth-Booth, of the Victoria and Albert Museum, has chronicled another major early collector, Chauncy Hare Townshend, and I discovered a more modest one in Alfred Capel-Cure, whose own 1850s photographs had survived in albums as family relics and whose copy of Fox Talbot's *Sun Pictures in Scotland* I rescued from a stack of papers that only bad weather had saved from a bonfire. Who knows what else in his collection had been destroyed before 1976? Alfred Capel-Cure is in some ways typical of a generation of well-to-do English gentry who took up the new art of photography. Many of them joined collecting clubs, and some of their albums, containing many fine photographs, survive. These amateur clubs included among their members some superb photographers, such as P.H. Delamotte, B.B. Turner, J.D. Llewelyn, Henry Pollock, and at least two who later became professionals: H.P. Robinson and Roger Fenton. Individual members exchanged photographs, and clubs mounted exhibitions and group exchanges. The surviving archives of these groups have proved to be an enormously important source of early photographic material.[1]

From the mid-1850s on thousands of middle-class Europeans and Americans collected photography after a fashion, purchasing carte-de-visite portraits, topographical, and art reproduction photographs for their various albums, and stereo cards for their viewers. But this kind of collecting was arguably a quintessentially Victorian pursuit, comparable with the late twentieth century's mania for television and video-tape.

Chauncy Hare Townshend, as Haworth-Booth has shown, collected photographs as an art form from the mid-1850s, keeping his Gustave Le Grays, a Giroux and a Silvy 'in presses with his other fine prints.'[2] His taste in photographs was subtle and subdued, reflecting his preference for landscapes and seascapes in painting and his interest in the documentation of contemporary events. Townshend was one of only a relatively

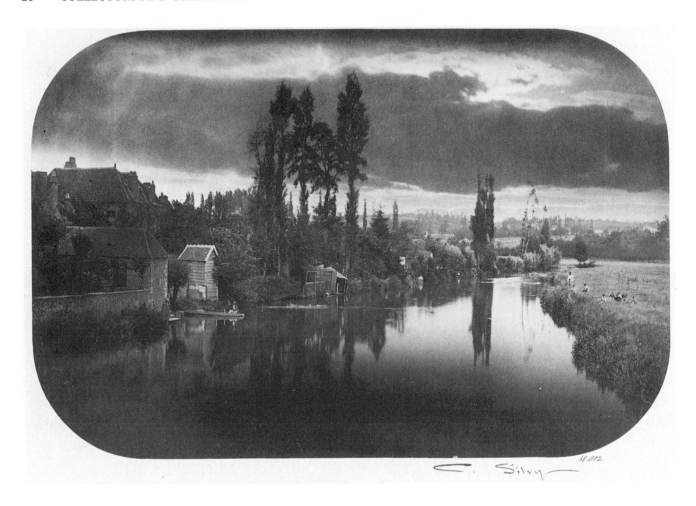

Camille Silvy. 'River Scene – France', albumen print, 1857, from the collection of C.H. Townshend. Note both here and in the Le Gray opposite the self-consciously artistic signing of the print by the photographer. Courtesy of the Victoria and Albert Museum.

few private collectors to purchase prints of Roger Fenton's photographs of the Crimean War; these, Haworth-Booth says, are 'the earliest mounted photographs in the collection.'[3] Other details of Townshend's collection are worth mentioning inasmuch as so little else is known about early collections of photographs; Haworth-Booth knows of 'no French or German collectors of fine photographs at this period.'[4] Townshend seems altogether to have eschewed the composite genre studies of photographers like Lake Price, H.P. Robinson, and O.G. Rejlander, of which Prince Albert was known to have been fond. His first purchases of landscape photographs were French, probably acquired in 1855, when he visited Paris to see the Exposition Universelle. They included Le Gray's *Tree Studies from the Forest of Fontainebleau* and a landscape by Albert Giroux, who won a bronze medal at the Exposition.

Townshend subsequently added two of the finest photographs of the decade to his collection, and these, though French, he probably saw in Britain. The first was Le Gray's *Sea and Sky*, 1856, which was shown at the London exhibition in 1857, and of which the *Journal of the Photographic Society* said 'It is as when a Jacob's ladder of angels was but just

Gustave Le Gray. 'Grand Vague – Cette', albumen print, *c*.1856. This fine seascape is from the same series as the 'Sea and Sky' in C.H. Townshend's collection. Indeed Townshend might have seen this print; it has a retailer's ticket on the mount, 'Macgill, Hanover St., Edinburgh'. It sold at Sotheby's London in 1978 for £3,500 ($6,300).

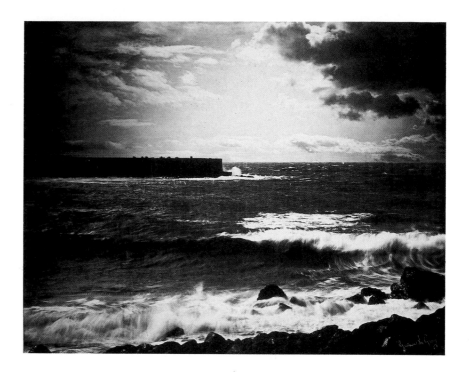

withdrawn, and the radiance above and below, where it rested on earth and sky, had not yet melted out.'[5]

The second photograph was Camille Silvy's *River Scene – France*, first shown at the Photographic Society of Scotland in autumn 1858, and hailed by a contemporary critic as 'perhaps the gem of the whole Exhibition ... the natural beauty of the scene itself, rich in exquisite and varied detail, with the broad, soft shadows stealing over the whole, produce a picture which for calm, inviting beauty we have not seen equalled.'[6] The picture also appeared at the famous Paris Salon of 1859, when photographs were first shown to the public alongside paintings. It caused the critic Louis Figuier to place Silvy at the head of contemporary landscape photographers and may also have been instrumental in bringing the wrath of Charles Baudelaire down upon the whole medium:

> the present credo of sophisticated people is this: 'I believe in nature and in nature alone.... I believe that art is and can only be the exact reproduction of nature.... So that any industry which could achieve results identical to nature would be tantamount to absolute art.' An avenging God has granted the prayers of this multitude. Daguerre was its messiah. And then the multitude said: 'Since photography gives us all the wished-for guarantees of exactitude (they believe that, the fools!) art is photography![7]

The great modern photography collector André Jammes suggests that Baudelaire was attacking only daguerreotypists and other commercial photographers. Doubtless the poet, like many artists and artistic photo-

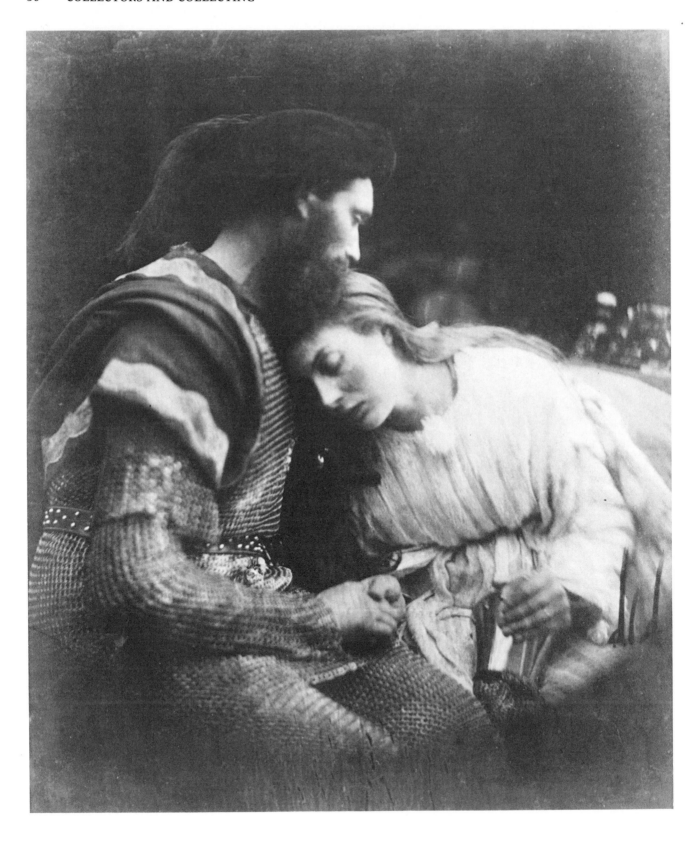

*Opposite* Julia Margaret Cameron. 'The Parting of Lancelot and Guenevere', albumen print from *Illustrations of Tennyson's Idylls of the King,* 1875. Encouraged by Tennyson himself, this two-volume folio demonstrated Mrs Cameron's determination to prove photography the equal of any other form of book illustration. Anecdotes about its production abound: my favourite is the one involving Tennyson's and Mrs Cameron's appearance at an event at the home of the Catholic Bishop of Salisbury. Mrs Cameron, spotting the Bishop across the room, cried 'Alfred, I have found my Lancelot.' To which Tennyson replied, in his penetrating and mellifluous baritone, 'I want a face well worn with evil passion.'

graphers of the period, was horrified at the proliferation of second-rate commercial portrait studios and the craze for stereo, but Jammes would have us believe that he accepted as fellow-artists 'these first skilful makers of the calotype, these archaeological adventurers, these investigators of historic monuments, these scrutinizers of the human countenance'[8], i.e. Nègre, Le Gray, Nadar, Du Camp and others. But it seems to me that Baudelaire's cry was against photography masquerading as art *in any form*; his critique was of photography as shown in the Salon, and his prescription was that photography 'must return to its real task, which is to be the servant of the sciences and of the arts, but the very humble servant, like printing and shorthand which have neither created nor supplanted literature.'[9]

Baudelaire seems to have triumphed, since little more was to be heard of artistic photography in France until the end of the century, and though Julia Margaret Cameron and Peter Henry Emerson resolutely championed photographs as art in England from the mid-1860s through the 1880s no more seems to have been recorded of individual collectors of artistic photographs until the 1890s. That there were a few is certain: Colnaghi's exhibited and sold Camerons at their galleries in the 1860s, and purchasers there undoubtedly were, above and beyond the lucky few to whom Mrs Cameron presented albums of her own and other photographers' work. But the absence of a clearly definable group of photography collectors in the latter half of the last century explains the present-day rarity of the works themselves. With few customers for their work, early artistic photographers tended to produce few prints, probably not many more than the average 1850s exchange club member. Still fewer of these prints have survived.

Even in the late 1880s, when photography began to respond to the Aesthetic Movement, most photographic artists were still men of independent means, not dependent on print sales to continue in their chosen medium. They sought mutual encouragement by collecting each other's work: thus George Timmins, of Syracuse, New York, collected some three hundred photographs by seventy-eight American and European photographers during the 1890s. F. Holland Day acquired some sixty photographs by his contemporaries, and by the end of the decade 'collecting by pictorial photographers was common enough for the Camera Club of New York to organize an exhibition exclusively of private holdings.'[10] Alfred Stieglitz in the course of his career formed what was probably the definitive collection of photographs of his era. In 1900 it contained about two dozen photographs, by 1910 the activities of the Photo-Secession had swelled it to some five hundred, and by 1933 it contained around seven hundred. Similarly Ernst Juhl, a German amateur photographer, organised ten exhibitions of pictorial photography between 1893 and 1903, and by 1910, when his collection was exhibited in Berlin, it contained work by more than sixty photographers from ten countries.

But where were the collectors who were not themselves photographers? Stieglitz ran his 'Little Galleries of the Photo-Secession', later '291', for small, select audiences. For the few photography collectors

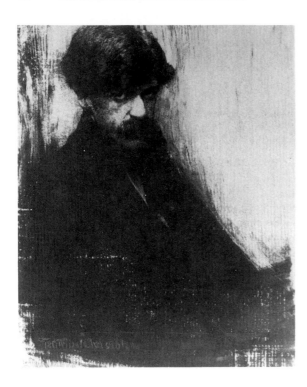
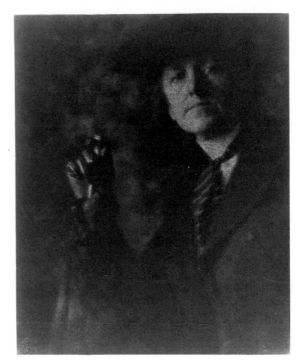

buying, Stieglitz could formulate impressive theories of connoisseurship, as for example in 1903, when he argued that collectors should 'acquire only pictures of really outstanding artistic worth', and that the quality of the individual print was the final determinant of value, there existing 'almost always ... one print that conveys the intentions and concepts of the artist more completely than any other.' These are good lessons for modern collectors, as is Stieglitz' statement that to acquire the single best print the 'collector should be willing to pay what might seem to be an excessive price. "What today may seem an exorbitant price can perhaps be thought of tomorrow as cheap."'[11]

Stieglitz could talk in theoretical terms about connoisseurship, and even cited a photographer selling a print in 1895 for $50 (£10) and three years later another from the same negative for $110 (£22), but apart from other photographers such buyers were so few and far between that Stieglitz' actual approach seems to have been simply to tell his gallery visitors 'I am not a salesman, nor are the pictures here for sale—though in certain circumstances certain pictures may be acquired.'[12] Stieglitz' own collection, comprehensively catalogued by Weston Naef in *The Collection of Alfred Stieglitz*, provides the essential prototype for any modern assemblage of late nineteenth and twentieth century photography. So profound was Stieglitz' influence throughout his fifty years as a photographer and gallery owner that it touched artists as diverse as Heinrich Kuehn and Paul Strand, Gertrude Käsebier and Ansel Adams.

In the years following the First World War collecting photographs became the serious concern of a few non-photographers. One reason for

*Above left* Gertrude Käsebier. Portrait of Alfred Stieglitz, pigment print on japan tissue, 1902, sold at Sotheby's New York in 1984 for $15,000 (£10,715).

*Above right* Alvin Langdon Coburn. Portrait of Gertrude Käsebier, gum and platinum print, *c*.1900. If Käsebier could photograph Stieglitz, then Coburn could photograph Käsebier, and so forth. Everyone could exchange prints, and collections were born. Courtesy of Thackrey and Robertson, San Francisco.

this was that nineteenth century material now began to attract antiquarian interest. In America Frederick Hill Meserve developed his great collection of American historical photographs, with important 1850s Mathew Brady portraits of Ralph Waldo Emerson and Commodore Perry as well as a comprehensive archive of Civil War portraits and scenes, many from the files of the Brady, E. & H.T. Anthony and Alexander Gardner studios. In 1925 in France Gabriel Cromer organised an exhibition which by accepting Nicéphore Niepce as the inventor of photography could claim the title *Centenaire de l'invention de la photographie*. Book collectors seeking such rare tomes as Teynard's and Le Secq's views of Egypt, or Fox Talbot's *Pencil of Nature*, began straying into the collecting of photographic ephemera: letters by Niepce and Daguerre, unusual daguerreotypes and, perhaps even a little reluctantly at first, the great paper photographs by such masters as Le Gray, Nadar, and others. Much of this 1920s and 30s activity occurred in France, Germany and Austria, and major collectors included the Frenchmen Albert Gilles and Victor Barthelemy, the Austrian Josef Maria Eder, and the German Erich Stenger. Both of the last two published histories of the medium, Eder as early as 1905, Stenger in 1939.

One of the greatest collectors of this period, who continued active through the 1960s, was the Frenchman Georges Sirot. Sirot recounted his first infatuation with photography in 1919, when, looking through material at a book sale, he discovered a portrait of George Sand by Nadar: 'George Sand was before me, with her beautiful eyes, but also with her masculine traits and her sensual lips. This lifelike image, so far from what I imagined, brutally explained to me [the fates of her lovers] Chopin, Musset, and the rest.'[13] Sirot became a major influence: he lived until 1977 and a number of his photographs found their way into the collections of André and Marie-Thérèse Jammes and others. As the Parisian art expert and photography dealer Gerard Lèvy recalls:

> Sirot sold—now I would say 'gave'—the Bibliothèque Nationale their biggest fund of photographs, about 30,000. He collected everything in photographs: thirty years ago when I got to know him anyone could, literally, walk on photographs at the Paris Flea Market. And so every Saturday morning at six o'clock we met each other. There were two or three other collectors at this time—we all met at the Flea Market, the best school. People had cartons full of photographs and at that time they wouldn't sell you one picture—you had to buy the lot. And so Georges, who had almost everything, and I would make deals. If there were two or three things he wanted he would take them; I would buy the lot, and he would explain it to me. He was not very rich, but he had a good eye and a fabulous memory. He was one of my closest friends.[14]

Erich Stenger was active in modernist photographic exhibitions in Germany in the 1920s, and as a result his collection was more varied and complex than some of those formed during the same period with specifically antiquarian intentions. André and Marie-Thérèse Jammes, active collectors since the 1950s, preserve perhaps a more antiquarian approach than most modern collectors, not altogether surprising in view of M.

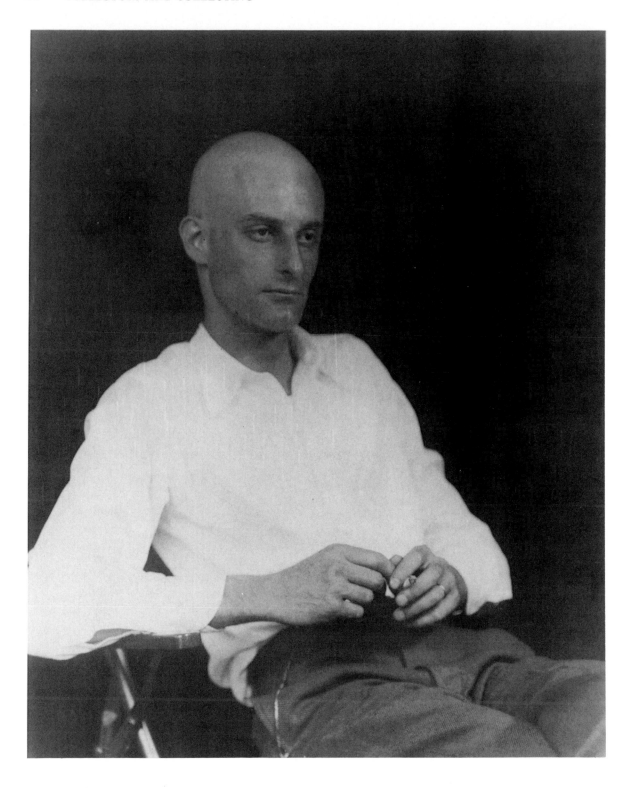

Berenice Abbott. Portrait of Julien Levy, silver print, 1927, sold at Sotheby's New York in 1985 for $4,000 (£3,333).

Jammes vocation as a rare book dealer. He and his wife believe that beyond the basic feelings of every collector are 'some that are personal and deep and move him forcibly. One of the most obvious of these is the desire to procure a work of art in order to preserve it from abandonment, disgrace, or destruction. A collection is often the result of the activity of one who realized that a certain form of artistic creation might fall into oblivion unless he, personally, were to save it from perishing.'[15] A selection from their collection was published in 1970 as an Aperture monograph, *French Primitive Photography*, and a second selection in 1977 as an Art Institute of Chicago exhibition catalogue, *Niepce to Atget. The First Century of Photography*. The latter is one of the most visually exciting photography books I know.

Helmut and Alison Gernsheim became photography collectors in 1944 at the prompting of Beaumont Newhall, and in ten years or so managed to accumulate probably the finest collection of nineteenth century British photography ever assembled. It is now at the University of Texas. John Pultz, in his essay *Collectors of Photography*, notes that the Gernsheims 'in their activities of preservation and monographic research, form a transition between cultural and modernist collecting.'[16]

Julien Levy, the great New York dealer, sold photographs along with other surrealist works of art in the 1930s, in much the same way as Stieglitz exhibited Braque and Picasso in his 291 Gallery. But the photographs in Levy's gallery were never meant to be dominant, though his own collection contained many photographic masterpieces, a testament to his perception of the artistic value of the medium. For the prototype of the modern collector of photographs as an art form we must turn to David H. McAlpin, born in 1897, who had the financial means and the determination during the 1930s and beyond to support a medium that for all practical purposes appeared to despise patronage. As Pultz states:

> Those who would collect contemporary photography after the demise of pictorialism were thwarted by two stylistic developments within photography. One was commercially oriented and found expression primarily on the printed page with little concern for original prints. The other was avant-garde; it insisted on the purity of art and refused to offer the public the documentary congruence between art and life that had motivated nineteenth century collectors. Not surprisingly, only a few individuals collected contemporary photographs in the period between the 1920s and the 1960s.[17]

McAlpin, an investment banker, took a direct and highly successful approach: he got to know his photographers. He met Ansel Adams in 1933 through the painter Georgia O'Keefe, bought six Adams photographs from his show at Stieglitz' American Place Gallery, and subsequently got to know, and collected work by, Edward and Brett Weston, Charles Sheeler, Paul Outerbridge and William Garnett. McAlpin subsidized the Museum of Modern Art's 1937 exhibition *Photography 1839-1937* and subsequently helped found the Museum's still-flourishing Department of Photography. With McAlpin we stand at the threshold of modern photography collecting.

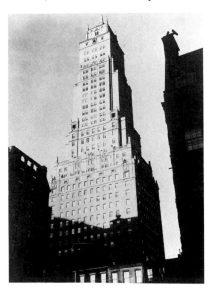

Charles Sheeler. 'Ritz Tower, New York', silver print, 1925. Courtesy Howard Read III/Robert Miller Gallery.

As an auctioneer entering the field of photography in the mid-1970s, there appeared to me to be two colossi in the domain of private collectors of photographs: Arnold Crane and Sam Wagstaff. The link between these two collectors was George Rinhart, a photography dealer who had the enormous advantage of having grown up with collector parents. Floyd and Marion Rinhart had produced the definitive study of patterned daguerreotype cases, 'Union' cases as they are often called, and from this background Rinhart was able to draw on connections to the world of photography collectors and amass an array of important, mostly historical, photographic material unavailable anywhere else in America. Rinhart worked closely with Arnold Crane, who began collecting in the mid-1960s, supplying Crane's collection with, among other things, the daguerreotype of Edgar Allan Poe originally offered at a Chicago auction in 1973, and apparently working closely with Crane in the acquisition from the photographer of the major archive of Walker Evans photographs. Crane, who in the space of a decade amassed a major collection of masters such as Hippolyte Bayard, Roger Fenton, Man Ray, Moholy-Nagy and others, as well as what Pultz calls 'idiosyncratic choices of work by unidentified and unknown photographers'[18] worked with his dealers in a quiet, almost reclusive way. I never met him.

George Rinhart was also a major source of supply for Sam Wagstaff, who has described Rinhart as the dealer 'I leaned on most heavily in the early days of my collecting. I always had a very solid occasion in George Rinhart. I never took everything he offered me, but he always had incredible material.'[19] Wagstaff dates his inauguration as a collector to the time of his visit to the Metropolitan Museum show *The Painterly Photograph* in the company of photographer Robert Mapplethorpe. *The Painterly Photograph* was, Wagstaff said, 'a revelation. I thought I disliked photography.' From this point Wagstaff developed into the most influential single force for the acceptance of photography as a collectable art medium. His background as an art historian and museum curator enabled him to approach the then-small world of photographic dealers and curators with an assurance that left others in the field more certain both of their own value as collectors, curators and dealers, and of the value of the medium itself. As a collector Wagstaff pursued such things as nineteenth century American stereo cards, worth perhaps $5.00 (£3.33) each, as enthusiastically as the Julia Margaret Cameron presentation album to Sir John Herschel, for which he bid £52,000 ($114,400) in 1974 (it was ultimately secured for the British National Portrait Gallery after an export licence was withheld and an appeal launched). Such a broad spectrum of interests created a sense of possibility for other collectors, and his own confidence as a collector enabled him to create, as he has said, 'some sort of entity—not a total entity by any means, because it eschewed a lot of people who were very well-known and well thought of, but who didn't happen to interest me particularly.' Among photographers 'eschewed' were such acknowledged masters as Paul Strand, Harry Callahan and others, but in their place Wagstaff found—and thereby perhaps created a market for—other photographic masters, early and modern. His selection of photographs for an exhibition at the

'Portrait of a Youth', by an unknown American photographer, salt print, c.1857–9. Courtesy of the Gilman Collection, and an example of that collection's concentration on works of 'intrinsic beauty'. Its photographer and subject are still unknown, but the Gilman catalogue suggests its 'appearance at a Boston auction supports the notion that the photograph was made in that city', perhaps 'as a symbol of the abolitionist cause'.

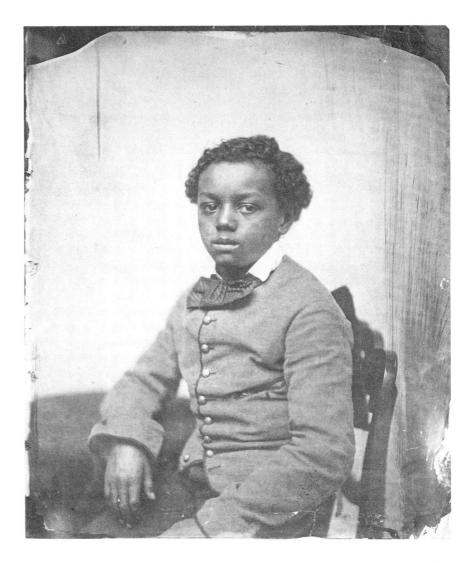

Corcoran Gallery in Washington D.C. in 1978, published as *A Book of Photographs from the Collection of Sam Wagstaff*, mounted a complex challenge to the conventions of 'value' in photography, even as Wagstaff himself was hailed by the press as 'the collector the establishment trusts.'[20] For Wagstaff as a collector in the 1970s, as he said in a 1985 interview, 'excess was my middle name.'

Sam Wagstaff may have been the last collector for whom the collecting of photographs presented, quite literally, limitless possibilities. There became, as he himself has said, little point for subsequent collectors to try to encompass the whole of the medium or, in his phrase, 'to go all over the map.' More recent collectors have usually specialized in one direction or another. Paul Walter's collection, exhibited at the Museum of Modern Art in 1985, began with European views of India, complementing his collection of Indian miniatures. From there he moved into photographs as works of art in their own right, especially those

nineteenth-century pictorialists whose work could be seen in a similar context to the prints of such artists as James Whistler, another interest of Walter's. But by 1977 Walter's interest had blossomed and he determined to acquire a representative collection of significant photographs. In the same year he wrote that photography 'is one of the few areas left in art—maybe the only area—where you can still put together a major collection of major works by major artists.'[21]

At about the same time as Paul Walter began collecting two important corporate collections were launched. Phyllis Lambert, of Seagram's distillers, decided to amass a major holding of architectural photographs of all periods, a task which under Richard Pare's curatorship has been impressively accomplished. Howard Gilman, of the Gilman Paper Company, in 1975 purchased a few twentieth-century photographs to complement the firm's art collection in other fields. Under the curatorship of Pierre Apraxine the collection grew, and Apraxine has written, 'with every acquisition we were in fact being drawn deeper into thinking of photography as an art unto itself.'[22] But the Gilman collection, as it became more broadly-based, always remained faithful to the principle of the photograph as an aesthetic object, a work of art:

> From the beginning the print asserted itself as a work of intrinsic beauty rooted in its own history. We sought the print contemporary with its negative, for it conveyed a more authentic feeling for the moment contained in the image. . . .
>
> As the collection grew in scope, we became aware of [its] not only becoming institutional in the depth and quality of its holdings, but [of its] also beginning to generate the kind of responsibility to its material that institutional collections should bear. More than ever, the collection itself was suggesting the lines of its own development. Beyond the actual collection there were the outlines of a shadowy 'ideal' collection which one would hope to approximate.[23]

The Gilman 'ideal' collection, as can be seen in the extraordinary richness of the offset lithographs in their book *Photographs from the Collection of the Gilman Paper Company*, is in many ways now a reality, and in my view represents the triumphant realization of an all-but-definitive aesthetic of photography. But it is by no means comprehensively historical. Apraxine has written that in British photography much had to be ignored in order to show what was truly remarkable in the British achievement: 'British imperialism and the British penchant for travel and collecting souvenirs meant that British photography flourished in Spain, Italy, the Caribbean, India, China, Japan, and other parts of the Far East. The enormous quantity of prints—most of indifferent quality— demanded a particularly discriminating approach.'[24] Such discrimination can be developed only by looking at thousands of photographs over several years; it is an essential, perhaps *the* essential, element in forming a significant collection.

The two individual colossi of the 1970s, Arnold Crane and Sam Wagstaff, in 1984 joined forces, without knowing it at the time, to become the major constituents of the newly-formed photography collection of

the J. Paul Getty Museum in California. In one fell swoop the Getty Museum became the repository of what its new photography curator, Weston Naef, called, according to the Los Angeles *Times*, 'possibly the best single collection in the world, because it consists of choices of choices.'[25]

The Getty's acquisitions were reputed to have cost the museum some twenty million dollars (£14,285,000), of which the lion's share went to Crane and Wagstaff. Other collections, apparently nine in all, were purchased at the same time through New York dealer Daniel Wolf. These included a Swiss one featuring daguerreotypes, an album from the estate of the 1840s British scientist and inventor Sir David Brewster, an assemblage of what the Getty called 'modernist American photographs (1885-1914)', a German collection strong in the work of August Sander, and two other named collections: German avant-garde photographs from the collection of Jurgen Wilde of Cologne and a Czech 1920s and 1930s collection from Wilhelm Schurmann of Aachen. The Getty's acquisitions brought it some 18,000 photographs. As Naef put it, 'The Met has Stieglitz. The Modern has Atget. And the difference between the Met, the Modern and the Getty will be that at its inception the Getty will have five or six collections that are equal to the single strengths of the Modern and the Met.'[26] This enormous purchase by the Getty Museum had a twofold effect on the photography market: it confirmed the position of photography as a collectable medium and at a single stroke removed an enormous number of prime collectables from the market-place.

Where does all this leave the present-day beginning collector? As dealer Daniel Wolf has said, the Getty purchase 'won't really change the market. When people are confident, the mood changes, and there'll be more money in the field [but] you need two big buyers to change a market, and the Getty won't even be one of them. There's very little it needs to add.'[27] It is worth noting that of the smaller collections which were part of the Getty Museum's purchase several were relatively specialized: 'modernist American photographs (1885-1914)', German avant-garde photographs, and so forth. This is the new thrust of the fine art approach to collecting photography, exemplified by, among others, John Waddell of New York, whose collection encompasses only the major work of photographers active between the two World Wars. At the same time many new collectors are still attracted by the antiquarian side of photography collecting; 'seeing' and in a sense 'possessing' history is a potent attraction. Most of the avenues open to collectors will be approached in later chapters of this book, but an important part of any collector's joy lies in establishing the unique direction of his or her individual collection. If you have discovered a wonderful arcane speciality unmentioned in this book, congratulate yourself. Most important of all, as Sam Wagstaff says, 'keep looking, and let the buyer beware.'

# 3. Areas of Specialization

ARCHITECTURAL AND TRAVEL PHOTOGRAPHS

In spite of the considerable publicity attracted by the development of the Seagram collection of architectural photographs in recent years, and the high prices certain architectural studies by photographers like Roger Fenton, Paul Strand and Charles Sheeler have fetched both through gallery sales and at auction, I believe that architectural photography as a genre can still be described as an under-collected field. It is not altogether unreasonable to compare its present state with the unlikely possibility of there being only one major collector of sixteenth and seventeenth century prints and a few others prepared to buy only Rembrandts and Dürers. This is not to denigrate those smaller collectors, unknown to me, who with great foresight are quietly acquiring many unsung treasures. Architectural photography remains one of the richest mines in the photographic world: choose any tunnel and you are likely to strike gold.

The problems of recording architectural monuments plagued the earliest photographers. 'Lured by hallowed reputations, photographers stationed their instruments in front of abbeys, castles, palaces, beauty spots—and came away with untidy evidence of building projects, repair work, scaffolding, stonemasons' yards, street trade and tumbledown housing.'[1] A prototype of these difficulties is Fox Talbot's *View of the Boulevards at Paris*, 1843, Plate II in *The Pencil of Nature*, where Talbot himself notes that 'a whole forest of chimneys borders the horizon: for the instrument chronicles whatever it sees, and certainly would delineate a chimney-pot or a chimney-sweeper with the same impartiality as it would the Apollo Belvedere.'[2]

In spite of the camera's inability to select what it recorded, architecture was in many ways ideally suited to the technology of early photography. It was both immovable and monumental, so early photographers had all the time they needed to establish an all-too-often elusive control over their photographic ingredients: light, shadow, framing and perspective. The introduction of human figures often posed problems, and it may have been the Scottish partnership of D.O. Hill and Robert Adam-

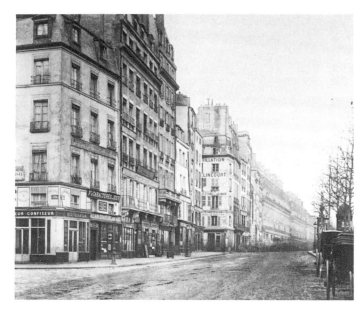

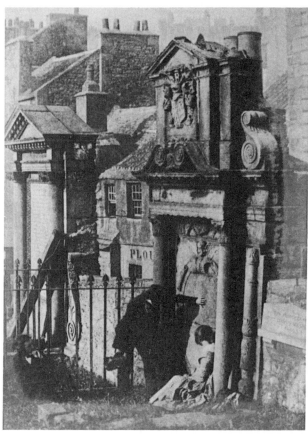

*Above* Charles Marville. 'Quai de l'Ecole', albumen print from a paper negative, early 1850s, a typically untidy architectural study, carriages, street trade, and all.

*Right* D.O. Hill and Robert Adamson. The Covenanter's Tomb, Greyfriars, Edinburgh, salt print, *c*.1845. Hill, a painter, showed consummate skill in posing human figures, including in this photograph himself, to focus the viewer's attention and place architectural monuments in perspective.

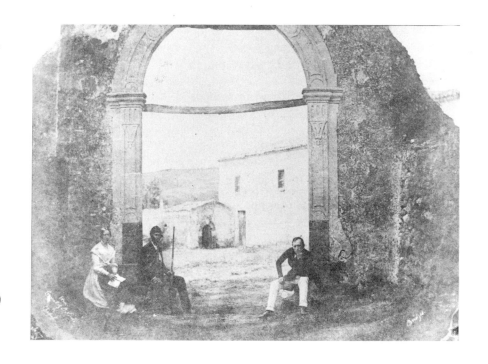

Revd George M. Bridges. Calvert Jones before the Convent of St Nicolo, Etna, salt print, *c*.1846. Calvert Jones and Bridges were both early practitioners of the calotype. The three quite different figures here give an agreeable impression both of the gentility of the English touring party and (note the rifle) the potential dangers of the neighbourhood. Courtesy Thackrey and Robertson.

son who first saw the solution to the problem of the human element. When controlled, and Hill and Adamson's control was often exquisite, the human figure could become an essential part of a photograph's compositional drama and scale. Hill and Adamson's photographs were taken in the mid-1840s, and by the early 1850s, when travellers like Henri Le Secq began to visit Egypt, figures, more often than not single figures, provided points of reference for all but the most imposingly photogenic of monuments.

These early years of photography offer many treasures—alas many of them expensive—for the architectural collector. Talbot published his 'untidy' Paris street scene in *The Pencil of Nature* in 1844, and there are a few architectural studies to be found in his *Sun Pictures in Scotland* of 1845 and the various calotypes published in the *Art-Union* in 1846. In 1851 major French photographers like Gustave Le Gray, Edouard Baldus and others were appointed to document the architecture of France by a government agency. At about the same time Charles Marville began recording his haunting and evocative street scenes of Paris, Charles Nègre his studies of the Midi, some of which were published in 1854, Felix Teynard and Henri Le Secq their monumental records of Egypt, and Auguste Salzmann his studies of old Jerusalem. Soon Robert Macpherson was active in Rome, Roger Fenton and others in Britain, Charles Clifford in Spain, and Linnaeus Tripe in India. By the early 1860s Felix Beato and John Thomson were active in the Far East, and Desiré Charnay began photographing ancient ruins in South America.

If the United States is notably absent from this list of photographers and their subjects it is because comparatively little architectural work was produced there in the earliest days of photography. Some magnificent architectural daguerreotypes survive, but all those I have seen have long since been assimilated into major institutional collections. In the United States, just as architectural photography might seriously have got started, the country was plunged into civil war, and practitioners like Mathew Brady, Alexander Gardner and George Barnard became instead chroniclers of five years of destruction. However impressive some of their photographs of devastated buildings are, they cannot in my opinion properly be called 'architectural'.

In Europe by about 1860 the quality of architectural photography began to decline even as its quantity increased. This can be largely attributed to the rise of stereoscopy: why bother with large and unwieldy photographs, however imposing, when one could insert a much less expensive rectangular card in a viewer and have the verisimilitude of three dimensions? Thus the 1850s are usually perceived as the greatest years of nineteenth century architectural photography, and the large-format albumen prints produced by photographers of the period are deservedly sought after. The original market for these large-format photographs was never great, as has been seen in Chapter 1 of this book; apart from institutional collections only a few other photographers and far-sighted individual collectors recognized them as the objects of beauty they certainly were. Purchasers also needed a substantial budget: Felix Teynard's *Egypte et Nubie: Sites et Monuments*, published between 1853

Edouard-Denis Baldus. Le Pont du Gard,
salt print, early 1850s.

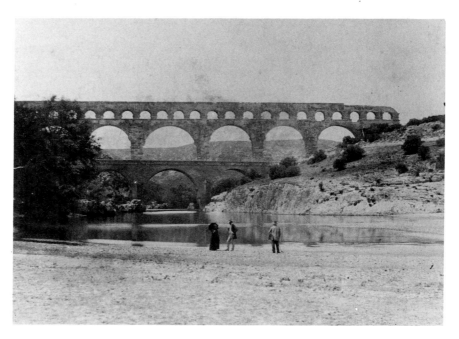

Auguste Salzmann. 'Jérusalem. Rue du
Quartier Arabe', Blanquart-Evrard salt
print, c.1855, sold at Christie's South
Kensington in 1985 for £250 ($300).

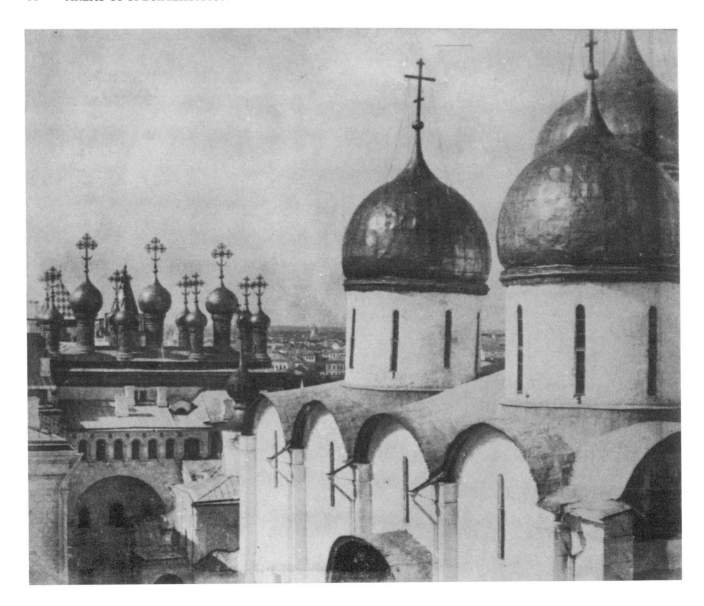

Roger Fenton. Domes of Churches in the Kremlin, Moscow, salt print, 1852. One of the great architectural photographs of the decade, if not the century, Fenton's elevating his camera to the rooftops of Moscow for this study creates an airiness that perfectly complements the exuberant architecture of the domes themselves.

Captain Linnaeus Tripe. 'South Façade, Rajrajesvara Temple, Tanjore', albumen print, 1858. If the first photograph in this chapter showed how unruly the architectural landscape could be, this one displays yet another hurdle for the architectural photographer. Faced with a monument the size of this temple, how does the photographer fit it all in?

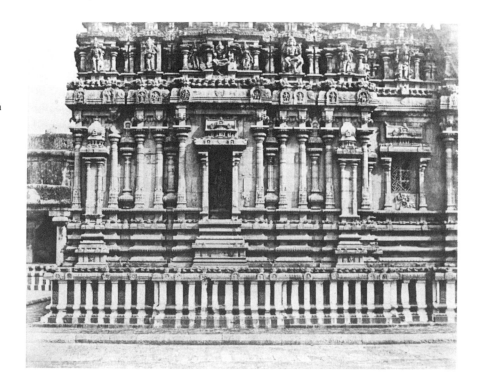

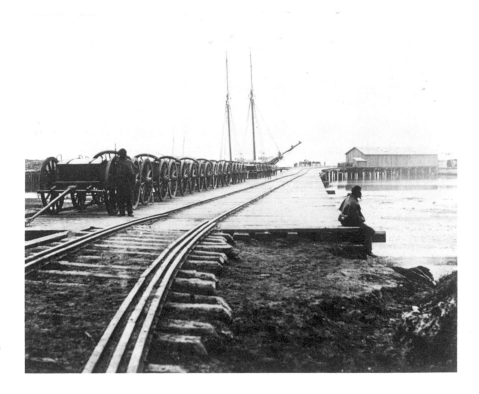

Mathew Brady or assistant. Supply wagons in Virginia, near the end of the Civil War, albumen print, probably 1865. Without showing anything other than the merely routine, this photograph seems to me to convey a powerful sense of the futility of the war.

and 1858, cost 1,000 gold francs upon publication, and large-format studies in England could cost half-a-guinea each or more—at a time when Dickens's young David Copperfield was earning six shillings a week.

But perhaps more important than the financial deterrent was the fact that even in a decade when Queen Victoria's consort actively collected photographs there was little public appreciation for these 'architecture as art' productions of the period. In more than ten years of watching the auction market I have seen only one copy for sale of P.H. Delamotte and Joseph Cundall's *Photographic Tour among the Abbeys of Yorkshire* of 1856, and only single copies of isolated annual volumes of the publications of the English 'amateurs'. I have never seen a complete copy of Teynard's Egyptian work for sale, though a fine single plate from it, of Abu Simbel, brought £1,400 ($2,380) in a London auction in 1977, and in the following year I learned that the Gilman collection had acquired a set of proofs of Du Camp's *Egypte* for a rumoured price of between $30,000 and $40,000 (£16,500-22,250).

A shift to a more mass-market approach in architectural photography was inevitable, and can probably best be seen in the work of Francis Frith. Frith first visited Egypt in 1856, and what became a four-volume work, *Egypt, Sinai and Palestine*, in two volumes, and *Lower* and *Upper Egypt*, each in one volume, began to be published in 1857. Frith's style is that of a tourist documenting his experiences in foreign lands; he is as excited about photographing a crocodile as he is about photographing the Pyramids, and taken as a whole his work provides a more intimate, smaller-scale, and much less imposing view of the Middle East than the work of the French photographers only half a decade earlier. Such intimacy, of course, was also the aim of stereoscopy, and Frith produced stereo cards of many of the same subjects depicted in the roughly 6 × 9 in. photographs mounted in his books and in his much rarer mammoth-plate (15 × 19 in.) views. It was a kind of photography-as-pabulum: the buyer could choose the fare he found most digestible.

Once into the 1860s, therefore, architectural and, more generally, travel photographs began consistently to be produced in smaller formats to suit the convenience and budgets of tourists, both the active and the armchair variety. Italy was, of course, a favourite object of the grand tour, and albums containing architectural work by such photographers as Alinari, Giorgio Sommer, Carlo Ponti and others are readily obtainable—in the 1970s and early 1980s albums of fifty or so 8 × 10 in. photographs rarely sold for more than a hundred pounds, or two hundred dollars. Similar albums depicting other parts of the world are not difficult to come by, though normally more expensive: world travel albums tend to sell according to the date of the voyage (the earlier the better) and the desirability of the places depicted in the photographs. Japan, Germany and the Americas are perhaps tops on this list. Although the photographic subjects of these albums vary, and many individual photographs will be of no architectural interest, mixed travel albums are the best sources of substantial quantities of early material at one time. Occasionally a wonderfully intense image leaps out from an album page,

Andrew Joseph Russell. 'Mormon Turnpike Bridge', albumen print from *The Great West Illustrated . . . along the Line of the Union Pacific Railroad,* 1869. The years after the American Civil War produced a number of adventurous photographers. Little is known of Russell except that, like so many others, his ambitious photographic project was a commercial failure, and only this first volume, containing fifty photographs, ever appeared. It sold at Christie's East, New York, in 1982 for $38,000 (£21,111).

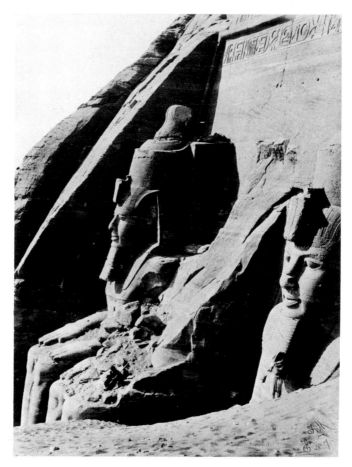

Francis Frith. Ibsamboul, albumen print from *Egypt and Palestine,* 1858. Frith seems deliberately to have chosen a perspective that makes the monument seem smaller and more intimate than it appears in Maxime Du Camp's photograph of only half a decade earlier (see page 15).

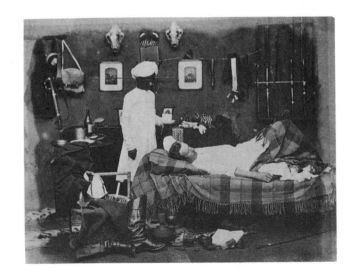

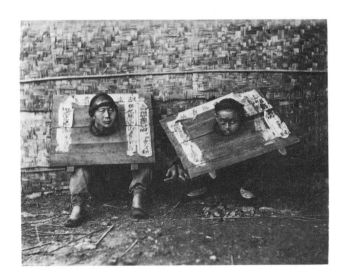

*Opposite left* 'Time to get Up', from an album of about 130 photographs of the British Raj, all from the 1860s. The collection sold at Sotheby's London in 1982 for £200 ($360).

*Opposite right* Travel albums occasionally contain, as here, studies of more sociological than topographical import. This one is from an 1870s album of Chinese and Japanese photographs.

*Opposite* Sergeant James McDonald. 'Wady Mukatteb', albumen print, 1864 or 1865. Army engineers of all nationalities often took, as here, highly competent photographs. This one was taken as part of the British Royal Engineers' ordnance survey of Jerusalem.

but sadly, in my view, the quality of most photographs in travel albums, from country to country, is all too often uninspired.

I have always thought that an attractive procedure for a beginning collector of 1860s and later architectural albums might be to put together one's own grand tour. Places one has visited could be the focus, or one could visit the places portrayed in the albums. Another possibility might be to purchase a dated tour album and attempt to elaborate on its photographs of architectural sites with local or regional albums of about the same date. As in other areas of photography collecting, condition is an important factor in establishing the desirability of these albums. Albumen prints with no tonal range are unlikely to have any long-term appeal, and though many albums contain such sloppily-produced prints it is always possible, through perseverance, to find better-printed or better-preserved examples.

The beginning collector of these and other early architectural studies will encounter a number of problems. The first one, emphasized throughout this book, is condition: almost all of the calotypes produced at Talbot's establishment at Reading have faded, the survivors of the thousands produced for the *Art-Union* perhaps worst of all; others in *The Pencil of Nature* and *Sun Pictures in Scotland* display uneven levels of fading from plate to plate and sometimes even a certain blotchiness on individual images. There are similar problems with the work of Talbot's contemporaries, such as Nicholas Hennemann and Calvert Jones, whose work was sometimes printed at Talbot's Reading establishment. In France many of the early architectural studies were printed at Lille by Blanquart-Evrard, and by the time the first French photographically-illustrated book was produced (apparently not until 1852) printing standards were considerably higher. The print quality of photographs found on Blanquart-Evrard mounts is often as high as that of the unpublished contemporary work to be found in albums, sometimes even as high as that of the unmounted prints which escaped the occasionally-devastating chemical reactions caused by acidic mounting boards and paste.

Condition is less likely to be a problem in the second major phase of architectural photography, beginning in the 1880s and 90s and still continuing. Some tourist albums of the first decades of this period, unfortunately, seem to contain the same photographs as albums from earlier years, sometimes in even worse condition, but the considerable technical advances of the late nineteenth century enabled photographers generally to produce better, longer-lasting prints. 'Permanent' carbon printing was used in the 1870s by Thomas Annan in the production of his impressive series of architectural studies entitled *Old Glasgow*, and at about the same time Henry Dixon and James Bool began their series of views for the Society for Photographing the Relics of Old London. In the 1890s such meticulous craftsmen as James Craig Annan and Frederick Evans in Britain, and their successors in the Photo-Secession, brought a more pictorial, sometimes even romantic, approach to architectural photography. Subsequently such masters as Eugène Atget, Paul Strand, the German avant-garde Werner Mantz, and the American precisionist

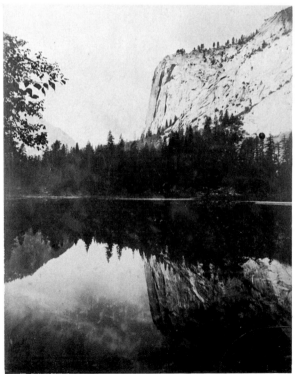

*Above left* Revd Calvert Jones. 'Bristol', salt print, late 1840s. An unusual street scene in exceptional condition.

*Above* L'Eglise de l'Hotel des Invalides à Paris, Blanquart-Evrard salt print, 1851, published in *Mélanges Photographiques*. Charles Marville may have taken this photograph, but there is no firm evidence either way. The strength and detail of the image bear witness to the success of Blanquart-Evrard's developing processes.

*Left* Carlton Watkins. Washington Column, Yosemite, later large-format albumen print by the Taber Co., San Francisco, from a negative taken by Watkins *c.*1864. These later prints, commercially produced for the tourist market in the 1870s and 1880s, are usually far less expensive and often in better condition than the earlier prints made by the photographers themselves, and make attractive collector's pieces.

Herbert Ponting. 'The Terra Nova in the McMurdo Sound', silver print, 1910–12. These large prints (this one is 23 × 29 in.) are much sought after by collectors inspired by Scott of the Antarctic. This one sold at Christie's South Kensington in 1984 for £320 ($448).

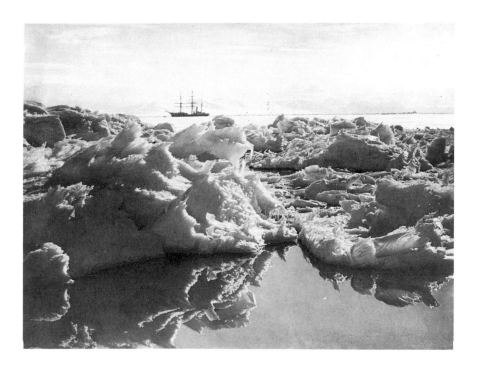

Timothy O'Sullivan. View of the Jungle and Members of the Darién Expedition Party, albumen print, 1870. O'Sullivan's eventful life as a photographer included documenting Civil War battles for the Brady Co. and, later in the 1870s, photographing the Rocky Mountains as part of the official American geographical survey. This study is one of a series documenting Thomas Selfridge's survey of the Darién Isthmus, which laid the groundwork for the construction of the Panama Canal. Two photographs from the series were sold at Christie's East, New York in 1981. This one fetched $5,000 (£2,380); another, far less powerful image with some slight tears to the print, fetched a tenth of that sum.

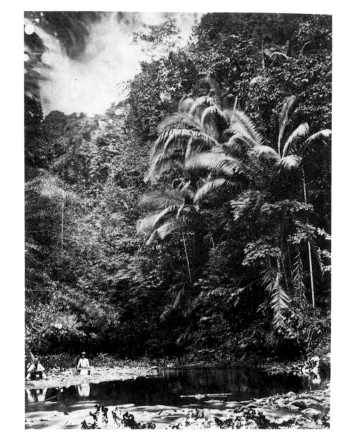

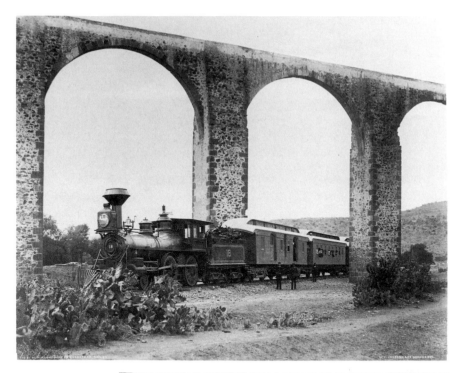

W.H. Jackson. 'Old Acqueduct at Queretano, Mexico', large format albumen print, 1880s. Jackson's views were popular with travellers from all over the world, but these large ones were very often framed and therefore particularly subject to fading. This unusually fine example sold at Sotheby's New York for $4,000 (£3,333) in 1985.

Frederick H. Evans. 'St Pierre, Rheims', platinum print, c.1900.

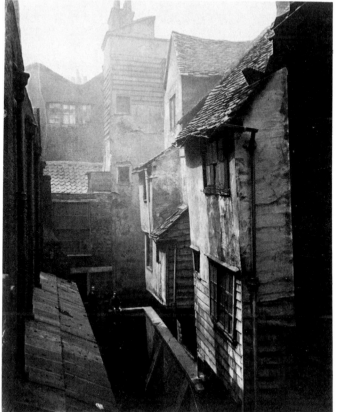

Henry Dixon and James Bool. 'Old London', carbon print from the series of 36 commissioned by the Society for Photographing the Relic of Old London.

Charles Sheeler brought the perspectives of the twentieth century to the subject.

Prices for works by these and many other photographers at the forefront of the field are high indeed—over $100,000 (£83,333) was rumoured to have been paid by a collector in 1985 for a Paul Strand study. Occasionally a substantial archive of work by a single photographer turns up and prices drop; in the mid-to-late 1970s it was possible to buy platinum prints by Frederick Evans for a hundred pounds ($180) or so, and signed hand-pulled photogravures by Alvin Langdon Coburn for a lot less. Those days quickly passed, and the mid-1980s saw fine examples of Evans' work bringing upwards of $1,000 (£800) at New York auctions. The bulk of Charles Sheeler's work is presently stored in a vault in Massachusetts, the property of a private collector; if this collection is ever put on the market I doubt that Sheeler prices will sustain the current auction levels of $40,000-$50,000 (£26,000-33,000) or more.

These well-known masters need not detain the beginning collector in the field. Many photography dealers can produce a drawer or two filled with architectural material produced prior to the Second World War, all of it at comparatively modest prices. Anyone interested in more recent developments in, and practitioners of, architectural photography could do far worse than simply to contact local firms of architects and ask about their photographers, or scan the pages of architectural magazines for photo-credits. The rest is up to you.

## DAGUERREOTYPES AND AMBROTYPES

For the beginning collector of daguerreotypes and ambrotypes this book can offer little beyond technical assistance. Reading the glossary of terms given on pages 127-47 should enable you to identify the various processes used without too much trouble, and I have briefly discussed some of the problems concerning daguerreotypes in the 'Forgeries and Frauds' section of Chapter 6.

Looking at a fine daguerreotype is one of the most transcendent experiences in photography, with the shimmering evanescence of the image seeming almost to mirror the passage of time itself. But I must warn you that these magnificent images form one of the most over-collected fields in photography. If, by chance, all you are interested in is portraits of 'just plain folks', or you have decided on a specific area such as fashion or one of the others outlined in the 'Portraits' section of this chapter, you will find a plentiful supply to draw on, since some three million daguerreotypes per year were produced in the early 1850s in the United States alone.

Literally anything out of the ordinary in the way of daguerreotypes and ambrotypes—large plate portraits, outdoor scenes, stereos (except, perhaps, stereos showing statuary in the Crystal Palace after the 1851 Great Exhibition), celebrities, still-lifes, photographic jewellery, even ordinary portraits by uncommon identified photographers—will command high prices from dealers and fierce competition in the salerooms. If

A good example of the kind of architectural photograph available at relatively modest prices to the assiduous hunter, this shows the elaborate ventilating shaft erected in Southwark Street, London, c.1888.

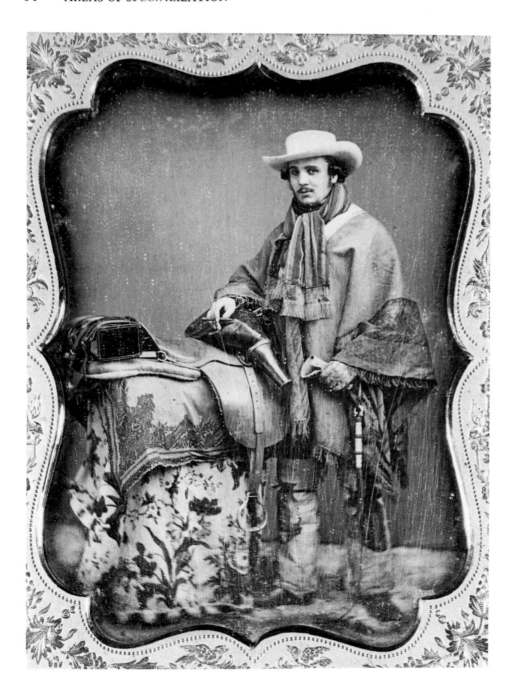

Half-plate daguerreotype of a young gentleman with his riding outfit, early 1850s. The daguerreotype is almost without doubt English, and it is tempting to imagine its subject, so nonchalantly posed with his cigar, about to set off for the Wild West. Alas, he may equally well be about to set off for the disease-ridden Crimea. Portraits like this have become increasingly rare, and have probably quadrupled in value since this example was sold at Christie's South Kensington in 1978, when it fetched £320 ($576).

An exceptionally fine hand-coloured
erotic half-plate daguerreotype,
certainly French, c.1850. Courtesy of
Thackrey and Robertson.

A daguerreotype bracelet, c.1850, in
unusually fine condition. The bracelet
itself is of braided human hair and I
remember, when I catalogued it in 1978,
feeling some concern as to whether the
hair was the young gentleman's or that
of his beloved; either way it seemed a
little spooky. This bracelet was sold for
£140 ($252) at Christie's in the same year
as the 'riding outfit' daguerreotype
opposite, and it too has probably
quadrupled in value since then.

The Duke of Wellington, sixth plate
daguerreotype portrait by Antoine
Claudet, taken on 1 May 1844 and 'said
to be the only portrait of him ever taken
by photography'. The case housing this
daguerreotype bears Claudet's '107
Regent St.' address, to which he moved
only in 1851, and the fact that there is a
daguerreotype of the same pose in the
Wellington family collection suggests
that this example may be an early copy
of the original, probably by Claudet
himself. Had this been the only known
specimen I suspect the price would have
been considerably higher than the
£9,500 ($13,300) it fetched at Sotheby's
London in 1984.

you are wealthy, determined, and endowed with inexhaustible patience, then cover as many possible sources as you can, and do not complain at the prices asked by knowledgeable dealers. Get to know what *modern* daguerreotypes look like—they have been known to be inserted in old cases and passed off as originals on an undiscriminating public—and beware any signs of tampering with the original casing. Three or four important daguerreotypes a year turn up at the major auctions, together with the occasional outstanding ambrotype, and when these have been historically significant their purchasers have at times had difficulty in securing export licences from European countries.

From the above it may be inferred that my counsel is 'doom and despair' as far as collecting important daguerreotypes is concerned. In the case of unimportant daguerreotype portraits by all means collect attractive or hand-coloured examples, or portraits from well-known studios, or collect them as illustrative of fashions or facial types. If you have morbid tendencies you will not find it difficult to amass a pile of death-bed studies, especially of babies.

I spent years in the auction rooms trying to persuade vendors to keep their daguerreotype and ambrotype portraits in their families, where future generations might take an interest in what their ancestors looked like even if the would-be vendors did not. Usually I failed. I came to dread seeing the things.

## PHOTOGRAPHIC BOOKS

The collecting of photographic books divides itself neatly into two categories: early books illustrated with photographs—either mounted or using early photogravure or photomechanical techniques—and books, old and new, on the history of photography, the work of individual photographers, and photographic exhibitions.

Significant opportunities remain for the collector of early books illustrated with mounted photographs, though most collectors will have to forgo the very earliest ones, dating from the 1840s and early 1850s. Such historical monuments as Anna Atkins's *British Algae*, 1843, Fox Talbot's *Pencil of Nature*, and the Blanquart-Evrard printed volumes by Du Camp, Teynard and others would cost—in the unlikely event they could be found—sums well into the tens of thousands. But a collection of the physically smaller, octavo and small quarto books beginning with, say, Piozzi Smith's *Teneriffe* published in 1858, and continuing with books illustrated with mounted albumen photographs published throughout the 1860s and into the 1870s, could be formed in the mid-1980s at a per-item cost of less than £500 ($750), and many of the more common books could be had for less than £100 ($150). Larger books, which tend to be broken up for their plates, and sometimes even small books of genuine rarity, will cost more: Alexander Gardner's *Incidents of the War* and Barnard's *Photographic Views of Sherman's Campaign*, both published in America in 1866, are rare and much sought after, but many of the editions of Francis Frith's folio volumes of photographs of the Middle East

Anna Atkins. 'Furcellaria Fastigiata', from *Photographs of British Algae Cyanotype Impressions*, 1843, the first photographically-illustrated book. This copy was presented by the photographer to the astronomer and photographic pioneer Sir J.F.W. Herschel, the same Herschel who received an album from Julia Margaret Cameron. It fetched £44,000 ($52,800) at Sotheby's London in 1985.

*Record of the Death Bed of C.M.W.*, by J. Walter 24 January 1844. The frontispiece, illustrated here, is apparently the first use of the calotype as book illustration, pre-dating by several months Fox Talbot's *Pencil of Nature*. This privately printed volume is now a great rarity, and the present copy fetched £2,200 ($3,080) at Christie's South Kensington in 1984.

Francis Frith. *The Gossiping Photographer at Hastings*, 1864. This is the photographic title-page, from a copy sold at Christie's South Kensington in 1984 for £400 ($560).

can be found for no more than the price of a copy of *Teneriffe*. Julia Margaret Cameron's *Illustrations to Tennyson's Idylls of the King*, 2 volumes, 1874-5 is impossibly rare now. Like P.H. Emerson's *Life and Landscape on the Norfolk Broads*, 1886, it is one of the great examples of artistic photography of the latter half of the nineteenth century. Both of these works are illustrated with mounted photographs, but Charles Darwin's *Expressions of the Emotions in Man and Animals*, 1872, illustrated with heliotype reproductions of photographs by O.G. Rejlander, and some of P.H. Emerson's Norfolk books illustrated with photogravures, notably *Wild Life on a Tidal Water*, 1890, are, along with many other books of the period, generally available at London auctions for well under my notional ceiling of £500 ($750). Monographs illustrating art treasures, paintings and sculpture especially, abound from the 1860s and 1870s and have usually been treated with contempt by both book and photography collectors. A splendid collection of these works could be formed as a way of illustrating mid-nineteenth century taste, at a probable per-item cost of less than £50, though I must confess it seems to me a somewhat academic and unrewarding prospect.

Twentieth-century monographs on photography, especially from the 1960s onwards, have in many cases not only documented the development of connoisseurship in the art but have also proved highly worthwhile investments in themselves. Monographs and illustrated works published by major photographers before about 1950, even when illustrated with dull and grainy half-tones, have become widely sought after and can cost up to several hundred pounds. But the publications of more recent years are a wide-open field for collectors. As Harry Lunn says,

G.B. Duchenne. *Méchanisme de la Physionomie Humaine, ou Analyse Electro-Physiologique de l'Expression des Passions*. Paris, 1862, with 21 photographs by the author. This is one of the great photographically illustrated books of the decade; the illustration shown here is from a copy sold at Sotheby's London in 1977 for £2,200 ($3,740).

For the collector with no more than two or three hundred dollars to spend at one time, the best buys are in photographically-illustrated books and the literature of photography. *The Decisive Moment*, for example, is now worth far more than when it was produced. One important factor for collectors is that publishers are often too pessimistic in their print runs, and the edition sells out with subsequently rising prices, or publishers are over-optimistic and a work gets remaindered, can be bought very cheaply, then goes out-of-print and becomes expensive.

Books are an undercollected field. Instead of having a few minor prints you will, by steadily buying the outstanding photographic books as they are produced, have at your fingertips more images to pluck out and enjoy than you could ever have using the same money to buy original photographs.[3]

To emphasize Mr Lunn's point it is worth pointing out that at a 1985 Christie's sale in New York I noticed a lot consisting of three paper-bound catalogues of French photography: André and Marie Thérèse Jammes' *The First Century of Photography*, 1977, *French Primitive Photography*, 1970, and the Bibliothèque Nationale's *Une Invention du XIX$^e$ Siècle*, 1976. I bought these as they appeared and they have been collecting dog-ears over the years. The three at Christie's fetched no less than $200 (£166), not a bad return on what cannot have cost the original purchaser more than a sixth of that sum.

Sir Richard Francis Burton, explorer, by Ernest Edwards, 1860s. This and other photographs in this section are cartes-de-visite unless otherwise specified. Some have been enlarged to show detail.

## PORTRAITS

A powerful incentive for photography collectors of the last half-century or so has been the impulse to see what people really looked like. Georges Sirot, as has been seen in Chapter 2, was initially moved to collect by a portrait of Chopin's lover George Sand, and Frederick Hill Meserve by a collector's passion for the faces of the American Civil War. Gerard Lèvy, a generation later, confessed that one of his first inspirations was a study of Sarah Bernhardt.

In a modest way I share this passion for faces. In the late 1970s I resolved to put together an album of carte-de-visite portraits of English Victorian authors, and I was lucky enough to buy about twenty of them in one group. Erich Sommer—of whom more later—kindly gave me an empty album, and soon I could turn its pages and gaze upon Dickens, Wilkie Collins, Thackeray, Bulwer Lytton and other luminaries. But this did not altogether satisfy me. I soon wanted as many different poses of my authors as possible, and I became frustrated at the apparent impossibility of obtaining 'cartes' of, e.g. George Eliot—her pseudonymity was only indifferently preserved, but she shunned the limelight of

Mrs Herbert Duckworth, by Julia
Margaret Cameron, cabinet portrait, late
1860s. The gilt border and
photographer's logo give these
small-format Camerons considerable
elegance, and Mrs Cameron's own
involvement with their production is
clear from her own manuscript
identification of the subject of this one.

publicity—and other authors like William Morris and A.C. Swinburne
who, though active in the sixties, really came to fame only in later
decades, decades featuring (to me) less desirable larger-format commer-
cial photographs. Soon I realized I could not resist other Victorians, and
sections of my album are now devoted to musicians—Verdi and Wagner
are particular prizes—and artists such as Holman Hunt and J.E. Millais
(Rossetti, to my rage and despair, eludes me still). Unlike the original
celebrity albums compiled by the Victorians themselves, mine has no
royal family at the beginning, and I am uninspired by the visages of poli-
ticians and military men. In 1982, while on a visit to Los Angeles, my
collection took a dangerous leap into the world of high finance: I paid
$12 (£6.66), a record price for me, for a carte-de-visite of Anthony
Trollope.

If you become enamoured of Victorian faces you had better be
prepared, nowadays, to pay more than $12 for good celebrity portraits.
But the field is so vast that there is no reason why, with care and
patience, you should not be able to put together a distinctive, perhaps
even a distinguished, collection all your own.

The most eclectic collector of Victorian faces I know is Erich Sommer.

Charles Dickens, by John and Charles Watkins, 1860s.

Sir J.F.W. Herschel, by Maull and
Polyblank, c.1860.

A.C. Swinburne, poet, by Elliott and Fry, *c*.1870.

Sir David Brewster, scientist and photographic inventor, by John Watkins, *c*.1860.

His collection of Julia Margaret Cameron portraits is without a doubt the finest in private hands, containing virtually all the most important subjects in the finest possible condition. From these 'macro' Camerons Sommer descended to the 'micro' Camerons: contemporary carte-de-visite rephotographings of her best-known portraits and groups. From these it was a short step for Sommer to begin collecting carte-de-visite portraits by other photographers. Indeed one of Mrs Cameron's contemporaries in the 1860s world of carte-de-visite portraiture was Camille Silvy, the same Silvy whose landscape formed such a lustrous part of Chauncy Hare Townshend's 1850s collection. Cecil Beaton has called Silvy 'the Gainsborough of commercial photographers',[4] and Silvy's work became a logical second focus for Sommer's collection. This now fills several dozen albums, and even extends to an extraordinary group of albums collected for their own physical features; elaborate mosaic inlays, Wedgwood medallions, even musical box movements can be among the incidental joys awaiting the collector of cartes-de-visite.

Miss and Master Glyn, and Sir Gordon Cumming, two carte-de-visite portraits by Camille Silvy, each in its own way showing his mastery of the art of portraiture. Both were taken in the early 1860s; the delicate hand-colouring on the portrait of Sir Gordon was probably executed in Silvy's studio, perhaps by an ex-miniature portrait painter made redundant by the advent of the new—and far cheaper—art of photography. Courtesy of Erich Sommer.

*101. Fiskedrager fra Bergen.*

*Above* Jules Leotard, the trapeze artist who created the garment that now bears his name, photographer unknown, mid-1860s. Courtesy of Erich Sommer.

*Above right* Gustave Courbet at his easel, by Etienne Carjat, *c.*1870. Courtesy of Erich Sommer.

*Right* A Bergen fisherman, by M. Selmar, *c.*1867. Courtesy of Erich Sommer.

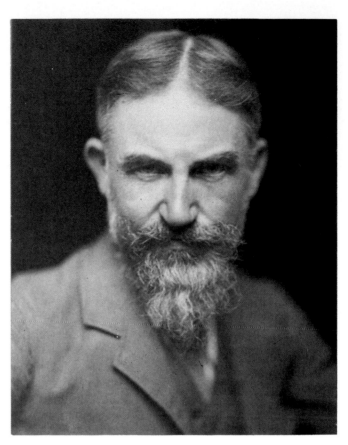

Almost any of Sommer's current collecting categories could become a speciality for someone with a more ordinary endowment of energy: apart from the Silvys, Sommer has albums organized by photographer, including Nadar, Disderi and Claudet; by profession, such as circus performers, actors, politicians, authors and artists; by historical events like the Paris Commune and the American Civil War; and by geographical areas such as Italy, Russia, Japan, China and Malaysia, including many posed scenes—spaghetti-eaters, opium dens and the like—produced for the tourist market. And of course there are albums of royalty, of which some contain 1860s studies from India and the Far East displaying an exoticism unmatched by almost any other photographs I have seen.

I have concentrated on cartes-de-visite because it is in this medium and its successors, the cabinet portrait and other larger-format commercial portraits, where the collector has the greatest opportunity to acquire the faces of celebrities as well as unknowns. As recently as 1985 it was possible to buy in the London auction rooms albums of perhaps one hundred cartes-de-visite, with perhaps fifteen or twenty celebrities among them, for under £100 ($120). Nineteenth-century portraits in other formats, probably not intended for the mass market, are and will remain far more expensive. But the scope for collecting these is still so varied that the occasional leap into a more expensive realm should

*Above left*  The Emperor of Solo, by Woodbury and Page, Java, mid-1860s. The influence of western culture may have been immediate and powerful— witness the fact that the Emperor is having his photograph taken—but his quintessentially Eastern regality and hauteur seem to me perfectly captured in this wonderful portrait. Courtesy of Erich Sommer.

*Above right*  George Bernard Shaw, by Lizzie Caswell Smith, platinum print, imperial cabinet size, *c.*1900, acquired by the author from a dealer in 1981 for £6 ($12.60).

Woman in a Bonnet Holding a Dead Bird, by Dr Hugh Diamond, taken in the Surrey County Asylum, albumen print, early 1850s. This print sold at Sotheby's London in 1984 for £6,500 ($9,100).

seriously be considered. Hugh Diamond's magnificent series taken in the Female Department of the Surrey County Asylum in the early 1850s, Roger Fenton's charming 1854 poses of the children of Victoria and Albert costumed for a pageant, studies by still-unidentified photographers of the famous Pre-Raphaelite models—all of these are too good to miss, as are the many possibilities for assembling larger-format commercial portraits (sometimes autographed) of personalities who have captured your historical imagination.

But if you seek an area where your per-item cost may be as little as a pound (or a dollar) or two try something in which celebrities and great photographers need not obtrude. I posed this as a question to Gerard Lèvy, who, without a moment's hesitation, said, 'Try fashion from cartes-de-visite to now, that would be a fabulous collection. Or children's dress of the nineteenth century.' Indeed in either of these fields it would be possible to go back as far as the daguerreotype era, in which anonymous small portraits, even hand-coloured ones, may be had for £25 ($37.50) or so. Such a collection could ignore the established 'names' of fine art photography, concentrating instead on the image itself and its relevance to the purpose at hand. Furthermore such a collection could be formed outside the usual circuit of inner-city galleries and auction houses, though of course many of the best examples in any field

'The Princess Royal and Prince Arthur as Summer', by Roger Fenton, albumen print, 1854.

*Below left* Jane Morris, posed by Dante Gabriel Rossetti, 1865, albumen print, sold at Sotheby's London in 1978 for £1,100 ($1,980).

*Below* Mark Twain, by Underwood and Underwood, silver print, 1907, inscribed and signed by the subject. Sold at Christie's South Kensington in 1984 for £550 ($770).

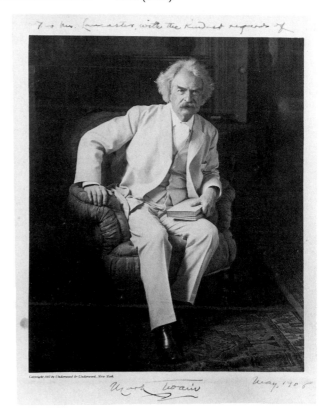

Claude Monet, by Choumoff of Paris, bromide print, c.1910. Signed by Monet on the mount, this photograph seems a spectacular bargain at the £110 ($198) it fetched in 1978.

George Bernard Shaw, four self-portraits, platinum prints printed by Frederick H. Evans, 1904. Courtesy of Hans P. Kraus, Jr. Shaw was fascinated by photography, and counted many photographers among his friends. The commercial portrait by Lizzie Caswell Smith on page 66 seems one-dimensional by comparison.

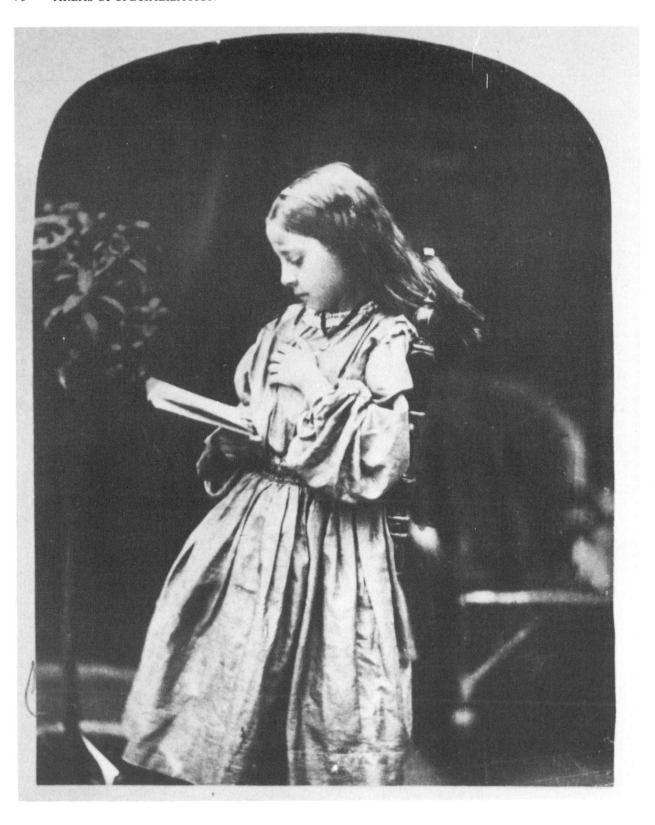

Oscar Wilde and Lord Alfred Douglas, silver print, late 1890s, sold at Christie's South Kensington in 1977 for £100 ($170).

*Opposite* The difference in price between an attributed and an unattributed photograph can be astonishing. This evocative study of a little girl reading, an albumen print of *c.*1860, seemed to me entirely in the style of Lewis Carroll. It is not at present attributed to him, however, and it fetched only £90 ($162) at a Christie's South Kensington auction in 1982, surely a worthwhile purchase either as the cornerpiece of a collection on children's dress, or simply as a gamble on the possibility of the photographer someday being identified.

*Right* Antoine Claudet and his sons Henry and Frank, posed at a table with photographic apparatus; stereoscopic daguerreotype, *c.*1851. This daguerreotype, sold with three others of the Claudet family, brought £12,000 ($16,800) at Christie's South Kensington in 1984.

are likely to gravitate to one or other of these venues. Along with stereo cards nineteenth century commercial portraits probably offer more collecting possibilities and a greater wealth of collectable material than any other fields in photography, and by defining your own collecting criteria you will have the double satisfaction of forming a unique collection and staying at least one jump ahead of the market.

## STEREOSCOPY

The stereoscopic craze swept Europe and, to a slightly lesser extent, America in the early 1850s. As far back as 1841 photographers such as Henry Collen and Antoine Claudet began making stereoscopic photographs for Sir Charles Wheatstone, the inventor of the stereoscope. But it was not until 1849 that Sir David Brewster perfected a 'lenticular' stereoscope that, by admitting light from only one direction, allowed ideal viewing of stereoscopic daguerreotypes. Claudet soon perfected a stereoscopic camera and became the foremost stereoscopic portrait daguerreotypist of the era. Within a few years stereoscopic daguerreotypes of all kinds were available, followed by stereoscopic ambrotypes and, in the later 1850s, the soon-to-be-ubiquitous stereo card. As the illustrations in this chapter show, more than one style of photographer rushed to embrace the new technology, 'the optical wonder of the age', as a contemporary critic called it.

The astonishing reality and solidity of these small double pictures, when viewed through a stereoscope, created a following for whom the illusion itself was sufficient to make a picture interesting and saleable. So powerful was the attraction of three-dimensionality that most photographers simply ceased to be concerned with the problems of artistic synthesis that had exercised their minds in the previous decade. Stereographic space had its own rewards.

An attractive, if rather silly, stereoscopic nude study, probably French, *c*.1850, sold at Sotheby's London in 1983 for £780 ($1,248). The harp, presumably, elevates it to the status of high art.

Sir David Brewster with stereo viewer; stereo card, late 1850s.

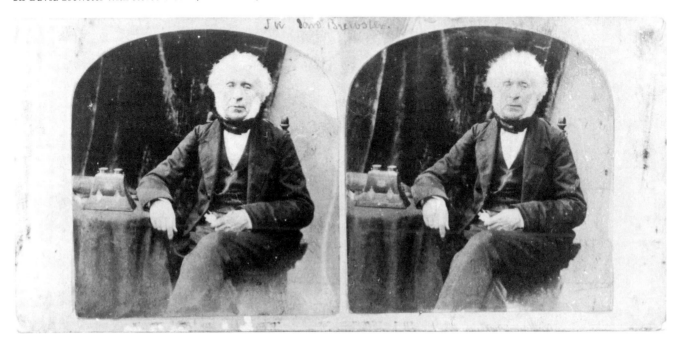

'The French Photographers' Gallery', a display at the 1862 International Exhibition; stereo card, sold by the London Stereoscopic Co.

Yet in spite of being condemned by contemporary critics as 'stereoscopic trash' and 'proof of a vitiated art taste'[5] stereo exerted, and still does, a unique charm. Gerard Lèvy has confessed his own addiction to stereoscopy: 'Stereo is to me the most sensual collecting area of photography, because it all comes to life. You can collect photography only if you are a Peeping Tom—in the best sense of the word and in the worst. And I am both. With stereo you really dig in. . . .'

Quite literally all the world awaits the stereoscopic collector. As a columnist wrote in 1861, 'Now, for an absurdly small sum, we may become familiar not only with every famous locality in the world, but also with almost every man of note in Europe. . . . The ubiquity of the photographer is something wonderful. All of us have seen the Alps and know Chamonix and the Mer de Glace by heart, though we have never braved the horrors of the Channel. The pyramids of Egypt would fail to astonish the most ingenuous of British schoolboys. We have crossed the Andes, ascended Teneriffe, entered Japan, "done" Niagara. . . .'[6]

In one area, at least, stereoscopy offered a subject-matter unexplored by any other nineteenth century photographic technique: humour. Sometimes trick photography with double exposures created 'ghosts', and at other times the subjects were pure kitsch. The work of some large-format artists, such as Rejlander, Lake Price, and H.P. Robinson, took a narrative approach, as in Robinson's *Little Red Riding Hood*, but nowhere else in the photographic *œuvre* of the nineteenth century was there the possibility not only of single-picture storytelling but also of storytelling via a series of images. Viewed through a good Victorian stereoscope the effects are usually amusing, slightly eerie and altogether irresistible, the closest thing to time travel I can think of. Stereo has for

photographs, mounted on stiff card and sometimes hand-coloured, or, less often, 'tissue' diapositives with cruder blocks of tinting to create a 'colour' effect as light was transmitted through the tissue. The second generation, beginning around 1890, are almost exclusively photo-mechanically reproduced cards, sometimes sold by the set in book-form cases. The historically-minded collector may want to consider these second-generation cards, which offer vast amounts of information on such subjects as technological innovations, World Fairs, industrial archi-tecture, the American West, the Boer War, and even the First World War. Their prices have remained very low, sets of several hundred cards fetching £50 ($75) or less in the London auctions of the mid-1980s. More elegant, though much rarer, material from the second generation of stereoscopy includes such things as stereoscopic autochromes and matching viewers, or fragile glass diapositives requiring the same kind of viewers as the earlier tissue cards.

But most stereo collecting has usually been confined to the period end-ing *circa* 1875. In 1854 the Stereoscopic Company was established in London for the sale of stereoscopic daguerreotypes and viewers, and within a couple of years the Langenheim Brothers had set themselves up in Philadelphia as the major American retailers in the field. Some 4,000 stereographers were active during the nineteenth century but, as collec-tors soon discover, many of the most attractive stereo cards and daguerreotypes are unattributed. The presence of a London Stereoscopic

'The Ghost in the Stereoscope', one of a group of six similar cards sold at Christie's South Kensington, along with about thirty other miscellaneous cards, for £65 ($117) in 1982.

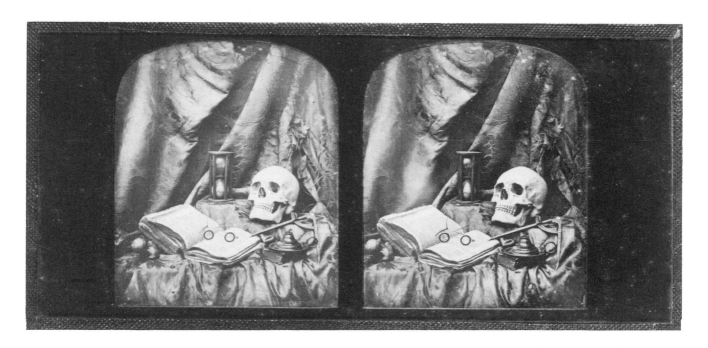

Vanitas, a stereoscopic daguerreotype usually attributed to T.R. Williams, *c.*1850.

Co. or Langenheim label is usually evidence only of the retail outlet, and even registry at the London Stationers' Office does not, as with, say, photographs by Julia Margaret Cameron, provide conclusive evidence of artistry: publishers like Michael Burr of Birmingham, who published stereos such as *My Country Cousin* and *The Troubles of Single Life*, may have employed a whole stable of stereographers.

Gerard Lèvy's advice to the stereo collector is to specialize: 'collect, for instance, destroyed monuments, things that are lost.' Other collections, which could easily number hundreds of cards, might have a geographical emphasis—the Far East or American West—or one could collect transport, or fashion, or humour, or city architecture. Stereo collectors are also fortunate in having some of the best-organized collectors' associations in all photography, and all those interested in the subject should consider joining one. An essential source of information on this subject is Russell Norton, whose address appears in the list of specialized dealers on p. 152.

George Hoyningen-Huene. Divers, modern bromide print by Horst P. Horst from a negative taken in 1930. Courtesy Staley-Wise Gallery, New York, which offers limited editions of these prints produced under Horst's supervision and signed by him.

# 4. Modern Photography

Anyone offering advice on collecting modern or living photographers may as well confess at once to subjectivity. My own taste is for fashion photography and still lifes, and while my favourite photograph in this chapter is Hoyningen-Huene's *Divers* I think the most beautiful one may be Peter Ruting's *Eight Bottles*. But if I had to say what I think is the most 'important' photograph shown in the chapter I would probably suggest William Eggleston's *Picture of Elvis with Kennedy Book*, and for the most elegant photographic craftsmanship I would not hesitate in choosing Robert Mapplethorpe's *Ken Moody—1983*.

Most historians would probably accept that Paul Strand's exhibition at Stieglitz' Photo-Secession Gallery in 1917 began what could be called the modern era in photography. The first phase of modernism, extending roughly to the beginning of the Second World War, includes such photographers as Strand, Edward Weston, August Sander, Laszlo Moholy-Nagy, Albert Renger-Patzsch, and Charles Sheeler, but of course many photographers active in the 1930s were still working in the fifties and sixties.

I think the most satisfactory approach to modern photography is to establish three groups of photographers for consideration. The first group, as described above, would consist of artists who either died or effectively stopped working around the time of the Second World War; some of these I discuss, along with earlier work, in Chapter 1. The second group would comprise photographers who produced a substantial body of work before 1960 but who in many cases were still making and/or signing prints into the 1970s and beyond. This category, of course, also includes many photographers who are still very active and have come to be regarded as 'grand masters'. In this category might be included Berenice Abbott, Ansel Adams, Diane Arbus, Richard Avedon, Cecil Beaton, Bill Brandt, Brassai, Manuel Alvarez Bravo, Henri Cartier-Bresson, Harry Callahan, Imogen Cunningham, Walker Evans, Robert Frank, Bert Hardy, George Hoyningen-Huene, Andre Kertesz, William Klein, J.-H. Lartigue, Clarence John Laughlin, Lisette Model, Arnold Newman, Irving Penn, Man Ray, Aaron Siskind, W. Eugene Smith, Josef Sudek, 'Weegee' (Arthur Fellig), and Minor White.

The third group would consist of contemporary photographers—many of whom are currently very 'hot'—whose major work began to appear after 1960. Among these are John Blakemore, Paul Caponigro, William Eggleston, Lee Friedlander, Ralph Gibson, Fay Godwin, Jan Groover, Robert Mapplethorpe, Duane Michaels, Nicholas Nixon, Cindy Sherman, Stephen Shore, Jerry Uelsmann, Gary Winogrand and Joel-Peter Witkin.

These lists are by no means intended to be comprehensive—any number of photographers could be added, and some of the greatest photographers' work, like Stieglitz' and Edward Steichen's, spans so many decades and styles that it simply defies categorization. There are also whole groups of artists left out whose work holds enormous possibilities for beginning collectors. What about the masters of Hollywood, who have given us a gallery of faces to rival that of Brady and the Anthonys' Civil War? What about the artists of fashion, like Erwin Blumenfeld and Louise Dahl-Wolf, whose work often has charm and even distinction, though seldom rivalling that of such masters as Beaton, Penn and Avedon, who have transcended the genre? These areas are well worth exploring, not least because their prices are usually far lower than those for more institutionalised masters.

Collecting photography does not require accepting a photographer's work in its totality. The lens and shutter captures any instant of a photographer's seeing—he or she need never develop a specific, instantly recognizable style, though photographers as different as Ansel Adams and Diane Arbus certainly did. Roland Barthes described his sense of sometimes being weighed down by the sheer mass of some photographers' output. Sometimes photographs became 'so indifferent to me that by dint of seeing them multiply, like some weed, I felt a kind of aversion toward them, even of irritation: there are moments when I detest photographs. . . . Further, I realized that I have never liked *all* the pictures by any one photographer . . . a certain picture by Mapplethorpe led me to think I had found "my" photographer; but I hadn't—I don't like all of Mapplethorpe.'[1]

With photography, especially with work by living photographers, it is possible to develop a collection that reflects *your* way of seeing, whose whole will be greater than the sum of its parts, however diverse those parts may be. Stay true to yourself, while remembering that collecting the work of living photographers is fraught with peril. As Sam Wagstaff says, 'That's where the ice is thin, obviously, and therefore it's the most fun place to skate.' Remember that it *should* be fun and you can never go entirely wrong.

Experts agree that contemporary photography is where much of the market's future lies. Robert Mapplethorpe's platinum prints—produced in a specific size and print substance in editions of only three—sold in 1985 for around $5,000 (£4,166) each. These tiny editions, as Harry Lunn says, are frankly 'not only limited but élitist, allowing collectors the cachet of demonstrating a preferred relationship with a dealer, and a certain social status.' These editions establish the definitive 'vintage' print, that is they demonstrate the highest level of the photographer's

William Eggleston. Picture of Elvis with Kennedy Book, dye-transfer print. Courtesy
Howard Read III/Robert Miller Gallery.

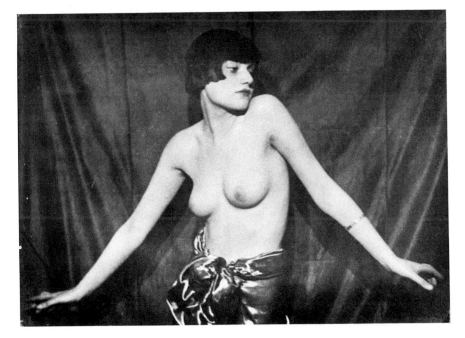

*Above left* August Sander. Portrait of the Painter Franz Wilheim Stewart, Cologne, silver print, 1928. Courtesy Howard Read III/Robert Miller Gallery.

*Above* Laszlo Moholy-Nagy. Photoplastik, silver print, *c.*1925. Moholy-Nagy called these photoplastiks 'photographs of complete collages, made of photographic fragments placed on a ground with the addition of graphic elements'. This one sold at Christie's East, New York, in 1984 for S2,600 (£1,857).

*Left* Man Ray. Portrait of Bronja Perlmutter-Clair, silver print, 1924. This enchanting photograph was taken during the production of the ciné-sketch *Adam et Eve*; Perlmutter-Clair's opposite number was played by Marcel Duchamp. Courtesy Gerard Lèvy.

Robert Mapplethorpe. Ken Moody, 1983. Courtesy Howard Read III/Robert Miller Gallery.

Paul Strand. 'Jug and Fruit, Twin Lakes, Connecticut', silver print, 1915. This photograph was directly influenced by Strand's exposure to Cubist painting at Alfred Stieglitz' galleries. Courtesy Gilman Collection.

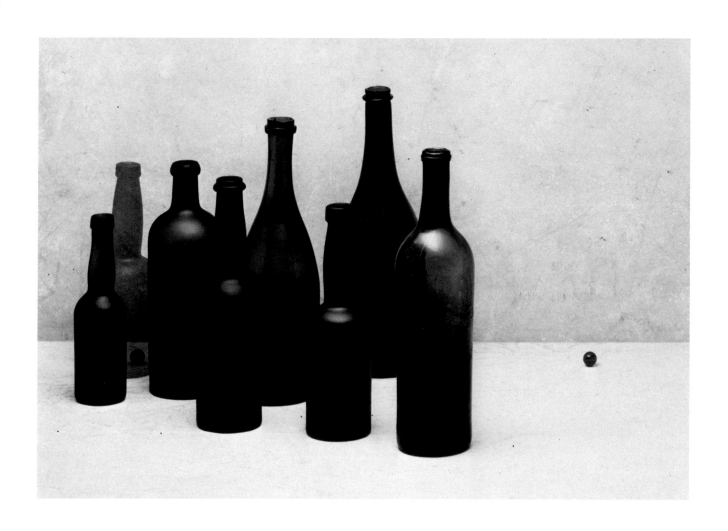

Peter Ruting. 'Eight Bottles'. Courtesy of the photographer and The Photographer's Gallery, London.

Edward Steichen. Nude with Narcissus, platinum print, 1902. Platinum prints by major photographers of the Photo-Secession are becoming harder and harder to find. This one was sold at Sotheby's New York in 1984 for $21,000 (£15,000).

Baron de Meyer. 'Elizabeth Arden, the Wax Head', silver print c.1940 from a negative taken in the 1920s. De Meyer photographs were selling at auction in New York in 1975 for as little as $100. This one, admittedly an exceptionally fine example of the photographer's work, fetched $5,500 (£2,500) at Sotheby's New York in 1980.

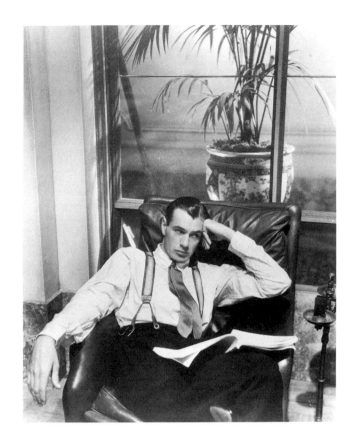

*Above* Imogen Cunningham. 'Triangles', silver print, 1928, sold at Sotheby's New York in 1983 for $14,000 (£8,750).

*Above right* E.R. Richee. Gary Cooper, modern print from a negative taken in the 1930s. Courtesy Staley-Wise Gallery.

print-craft as it existed at the time the original negative was produced. Later the photographer may, as Lunn points out, 'return to the negative and make an even more superlative print, but not in the same format or substance.' Purist collectors, as has been seen in the case of earlier fine-art photographs, will always covet the vintage print reflecting the state of the artist's mind at the time of creating the original image.

This élitist approach to creating photographic prints, with a high degree of rarity built in at the outset, obtains only in the highest echelons of the market, in the grandest art galleries throughout the world where photographers and their work are marketed in the same way as major graphic artists in other fields. Young photographers on their way up are likely to produce somewhat larger editions, and of course their prices will be lower—in some cases far lower—than those of the select few at the top of the market. Some of these young photographers will be scaling the heights of commercial success even as this book is published; some, unbeknownst to me, may already have reached the heights, in which case they can afford the grace of forgiving me the exclusion of their names here. A few may not maintain their achievement. What will become of Cindy Sherman if she stops making self-portraits? Will collectors want Jan Groover's recent work as much as they did her lustrous still lifes of kitchen utensils? Can the deliberate perversity of Joel-Peter

Jan Groover. Untitled, kitchen sink with plant forms, type C colour print, 1980. Courtesy Howard Read III/Robert Miller Gallery.

Helen Levitt. Untitled, New York, 1972, dye transfer print. Courtesy of the photographer.

Horst P. Horst. Model wearing Mainbocher's pink satin corset, modern limited edition print from a negative taken in 1939. Courtesy Staley-Wise Gallery.

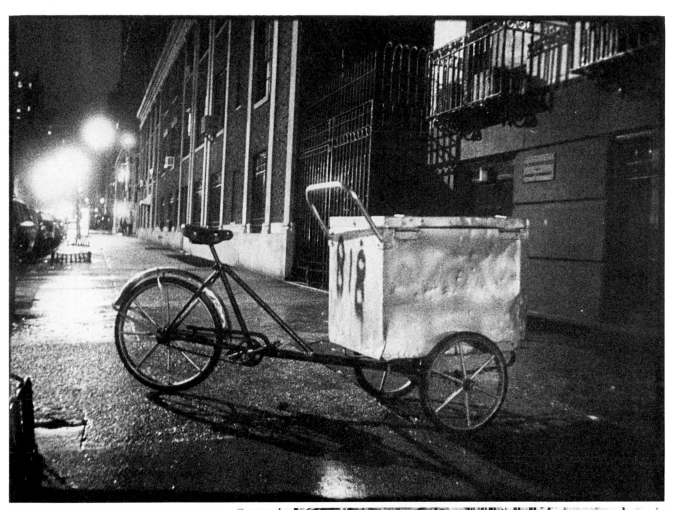

Bill Arnold. Untitled, a night scene, New
York. In 1985 Sam Wagstaff said 'I don't
know why Bill Arnold doesn't have a
gallery in New York. I find him one of
the most interesting photographers
going.' Courtesy of the photographer.

Mari Mahr. Untitled, from the series
'Idle Times'. Mari Mahr is one of a
number of contemporary photographers
(Peter Ruting and Fay Godwin are
others) whose work is to be found at the
Photographers' Gallery in London.

Witkin's composites remain as fashionable as they have been in the mid-1980s? It is hard to say.

You can get an idea of any current artistic pecking order by visiting a cross-section of major galleries, and I am not at all sure how valuable the information in the last few paragraphs really is for collectors. Listen to Sam Wagstaff: 'Just because a photographer has a show doesn't mean he's a good photographer. I know plenty of them who *don't* have shows and *are* good photographers. I think if you went into Leo Castelli or Light Gallery or Witkin and bought everything contemporary you'd make mistakes.' Developing the confidence to buy in accordance with your own self-approval is never easy, and you are bound to make mistakes. If your interest in photography is, so to speak, 'pure', that is if you feel not even the murmur of a question as to what the photographs you buy may be worth in five years or twenty-five years, then you should simply follow your taste wherever it leads you, within the limits of your purse.

Gallery shows may be your most important single source of material, and for photography New York is the most significant venue. If you are lucky enough to live in or visit New York, publications like *The New Yorker* provide comprehensive listings of current photography exhibitions in that city, and thus a useful guide to what is at centre stage. Most major cities will also have newspaper or at least some kind of magazine listings of current gallery exhibitions.

With the work of living photographers you may not be able to look for the red dots on the gallery walls to see what is selling; at most times additional prints will be available, so an indication of sales may not be posted. Some galleries use a red dot for each print sold, and a popular image in a show might have a half dozen dots next to it: I think this approach is both more honest and more fun.

Go to as many shows as you can, as often as you can. Compare prices, talk to photographers, eavesdrop on other people's conversations—that's what gallery conversations are for. You'll get an idea of what is 'hot', but more important (I hope) you'll get an idea of what other collectors care about and, most important, what you like. More experienced as well as less affluent collectors enjoy going to award shows sponsored by camera and film manufacturers, university and art college shows, and the occasional countryside art fair. As Wagstaff says, 'There are an awful lot of contemporary photographers that don't get a shake in the New York gallery situation. I'm always finding people whose work I like when I get out of the city—contemporary people, that is—and whether they will end up as bona-fide geniuses remains to be seen. But so what?' Wagstaff's 'So what?' is an important caveat when you venture outside the well-trodden gallery paths. Though a few major artists will always work outside the commercial circuit of the city—remember that Paul Strand and Edward Weston, for example, always did—an important fact of the market for young artists is that the number of photographers who would like to sell their prints far outstrips the number of people actively collecting them; in 1977 a proportion of about 1,500 photographers to one collector was suggested at a Kodak symposium! To avoid being

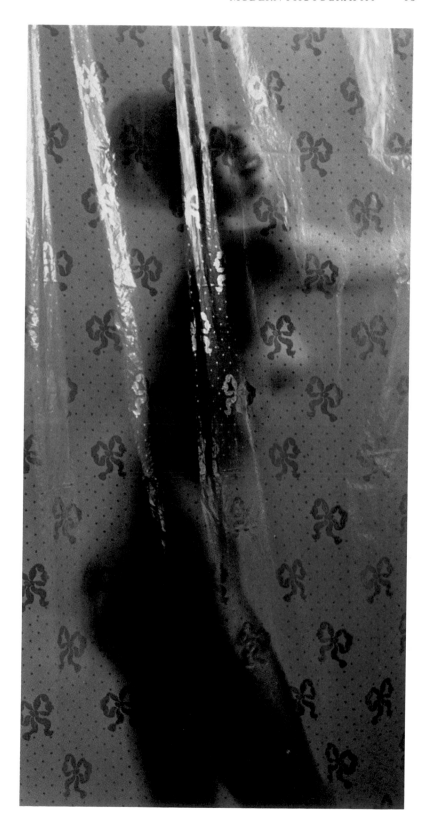

Paul Outerbridge. Shower for
Mademoiselle. Colour carbro
print, c.1937, now in the
collection of Sam Wagstaff.
Courtesy Howard Read III/
Robert Miller Gallery.

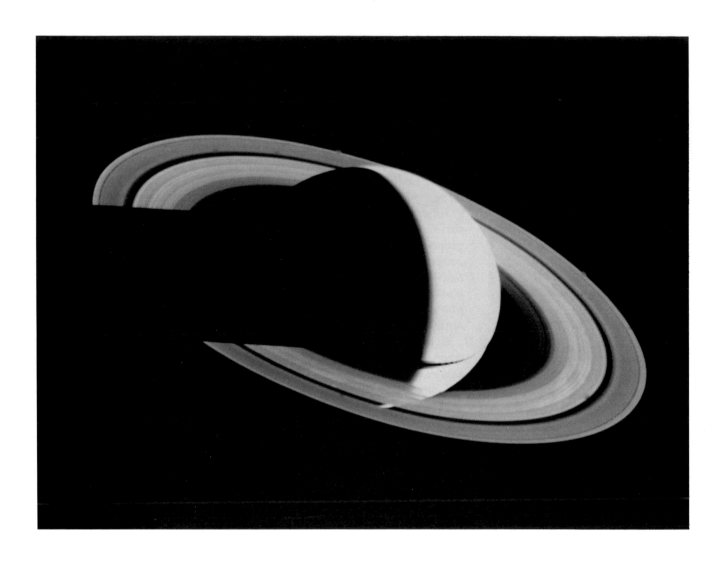

Saturn photographed by Voyager I, 1980. The planet's shadow falls on the rings from a perspective never before seen. Courtesy Jet Propulsion Laboratories, California.

André Kertesz. 'Aux Halles', silver print, 1929, signed by the photographer. Vintage prints by Kertesz are of great rarity, for reasons discussed in Chapter 1. This photograph fetched $16,000 (£11,429) at Sotheby's New York in 1984, but modern prints from early negatives could be had from the photographer prior to his death at much lower prices. Since 1985, however, prices even of modern Kertesz prints have soared.

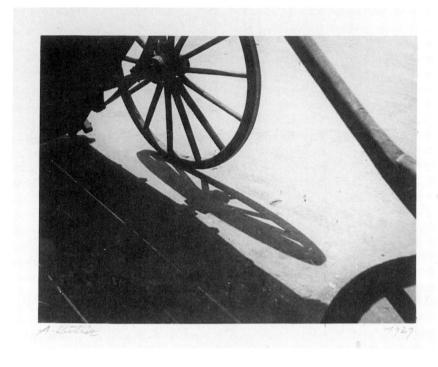

Edward Weston. Nude (Miriam Lerner), platinum print, signed, 1922.

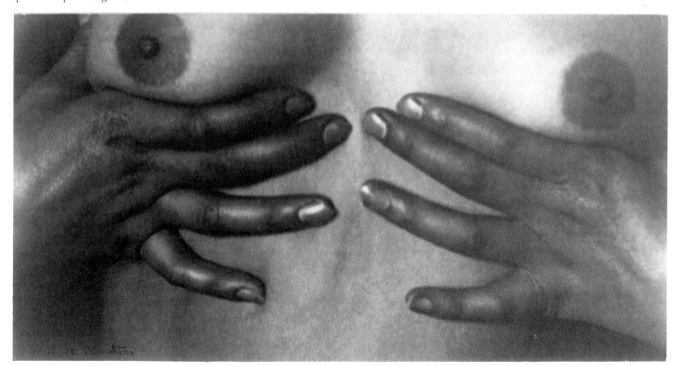

the most desirable 'breaks down with contemporary photography. A print made today by Harry Callahan from a negative exposed in 1948 or 1949 may be as good or better than a vintage print. . . . While it is doubtless true that many persnickety collectors will insist upon a vintage print, that insistence will in many cases be a personal preference rather than an aesthetic or investment choice.'[3] Harry Lunn to some degree concurs, citing the superb quality of the prints produced by Ansel Adams in the 1960s and 1970s from negatives in some cases taken as early as 1927. But even Ansel Adams's earlier prints have established themselves as more desirable: out of some 800 taken from the negative of his magnificent *Moonrise, Hernandez, New Mexico, circa* 1941, the highest price so far paid at auction, $22,000 (£11,000) was for a large-format print known to have been made not later than about 1959.

Some balance must be struck, obviously. Pierre Apraxine has enunciated what I believe should be the collector's ideal: to seek 'the print contemporary with its negative, for it conveys a more authentic feeling for the moment contained in the image.'[4] But Gerard Lèvy notes the practical problems of fulfilling this ideal: 'Before, say, 1975, all the living photographers I knew—and I know many—were producing one or two vintage prints from a negative and that's all. Kertesz has no vintage, Brassai n'a pas de vintage, Arnold Newman n'a pas de vintage. So.' Printing photographs is a messy and time-consuming business that a photographer is unlikely to undertake without reason. Once he has taken a photograph and made, if he had a commission, a print for his collector or publication and one or two for himself, he is likely to leave it at that. Some photographers are indefatigable experimenters, eternally in quest of the perfect print, and if they save the best of their experiments their vintage stock may be a little higher than average. But usually photographers make additional prints only if someone asks for them. The fact that people rarely asked for prints before about 1970 explains the desirability of these early examples: they are likely to have been commissioned by one of the few early connoisseurs whose collections, like David McAlpin's, are likely to be of importance; and because fine print commissions before 1970 were few and far between photographers were likely to lavish exceptional care upon them.

In the end it all comes down to connoisseurship, the same kind of connoisseurship involved in collecting earlier photographs and described in Chapter 1. But with living photographers one can have, if not the prime vintage example, at least the pleasure of buying a print supervised by the master photographer and bearing his signature. As Lèvy says, 'If you like the image, buy it. But don't hope to sell it tomorrow at a big profit. Play the game. It's nicer to have an image on the wall than a hundred-dollar banknote.' In the final analysis I disagree with Tennyson Schad: I believe that buying vintage prints is an important aesthetic choice and probably a wise investment decision as well. But if you are faced with choosing a 1965 or a 1985 print from a negative taken in 1950, and there is a substantial price difference, look closely at the two prints. The tonalities may vary and you may find yourself with a strong personal preference for one or the other. If your aesthetic sense tells you the later

Brassaï. Paris, an untitled scene from *Paris de Nuit*, published 1933, a rare vintage silver print, c.1930. Courtesy Howard Read III/Robert Miller Gallery.

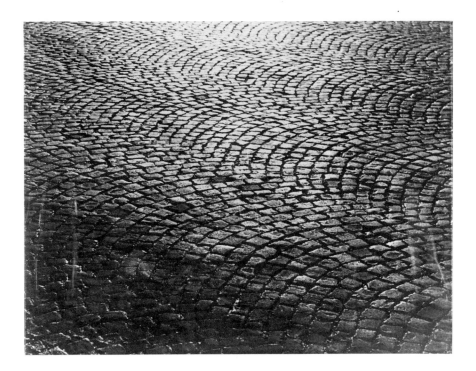

print is the better of the two, your judgement may be echoing the photographer's own. Ask the gallery owner; ask the photographer, but remember that the final decision is up to you.

4 **Colour:** colour prints used to be as unreliable as calotypes; nobody knew how long they were likely to last. Paul Outerbridge made permanent colour carbro prints in the 1930s—of which more is said in the appendix on processes at the end of this book—but until the 1970s few major photographers experimented with the medium for exhibition prints. Recent technological developments, such as Cibachrome, have enabled photographers working in colour to achieve much more permanent results without the labour and expense of the three-part dye transfer process. Some recent colour work is among the finest produced by photographers, and collectors and critics are finally accepting that colour is here to stay.

All these considerations gloss over the ultimate problem facing the collector: the aesthetic one. Many of the greatest works of art outraged the opinions of the artists' contemporaries, and you will have to be the final judge of whether what you are buying is frivolous but irresistible, a poke in the eye for the establishment, or an enduring work of art. Some of the best contemporary photographers bring to their work a deliberate perversity. Whereas the first photographers were astonished and delighted at their capacity to capture what they saw the jaded modern eye demands something more exotic. Weegee's photographs of the seamier sides of New York provide something of this exotic character, but one can look back to Atget or even to some of the 1850s masters for

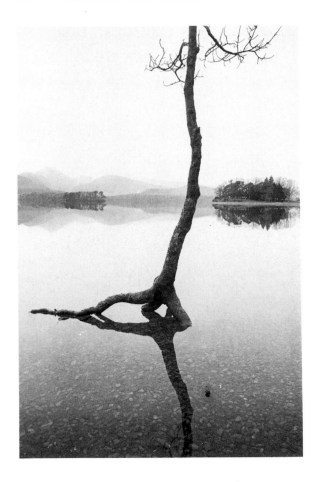

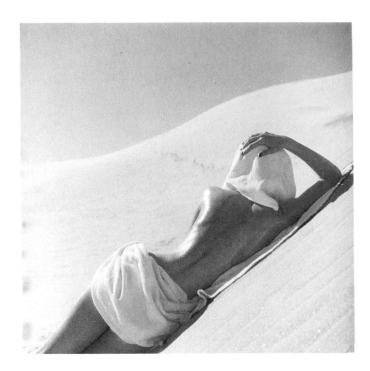

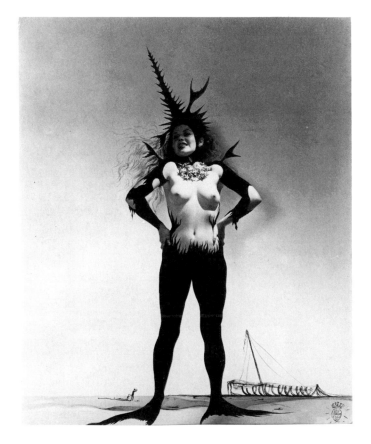

*Above* Fay Godwin. 'Flooded Tree, Derwentwater'. Courtesy of the photographer and The Photographers' Gallery.

*Above right* Louise Dahl-Wolfe. California Desert, modern limited edition print from a negative taken *c*.1950. Courtesy Staley-Wise Gallery.

*Right* Mixed media work can pose problems for the collector. This surrealist study for *The Dream of Venus* is the collaborative effort of Horst P. Horst, Salvador Dali and George Platt Lynes, and is dated and signed by Dali. Does it belong in a drawing or a photograph collection? Purists may ponder, but if I were a wealthy man I would add it, whatever it is, to mine. Courtesy Howard Read III/ Robert Miller Gallery.

their own kind of surreality. Diane Arbus pioneered, as it were, what I consider the modern perversity in photography: her photographs are arresting, then disturbing. Anyone looking at them has a window onto the photographer's unsettled and unsparing soul. Some even younger photographers have settled on a more directly outrageous, usually sexual approach. Some of these are among the most brilliant now working, and there is no reason why photography, any more than other art form, should conform to a genteel 'norm'. But it is worth remembering that though not all photographs need necessarily be for public display, art prices ultimately have something to do with what is perceived to adorn a wall. When in doubt you could do far worse than to remember the words of Walker Evans: 'Leaving aside the mysteries and inequities of human talent, brains, taste and reputations, the matter of art in photography may come down to this: it is the capture and protection of the delights of seeing; it is the defining of observation full and felt.'[5] Finally, if all this theorizing leaves you unmoved, consider the 'delights of seeing' that come with looking at NASA's photographs taken in space. Susan Sontag has described photography as 'something predatory', appropriate to a world in which 'nature has ceased to be what it always had been—what

Diane Arbus. 'Jack Dracula Reclining', vintage silver print. Courtesy Howard Read III/Robert Miller Gallery.

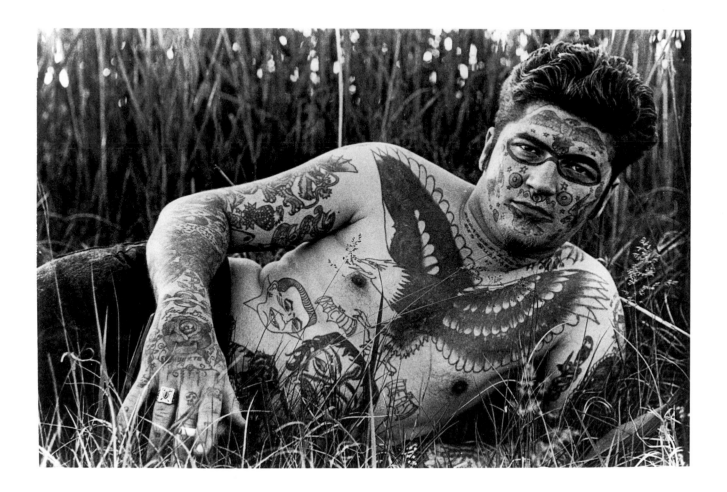

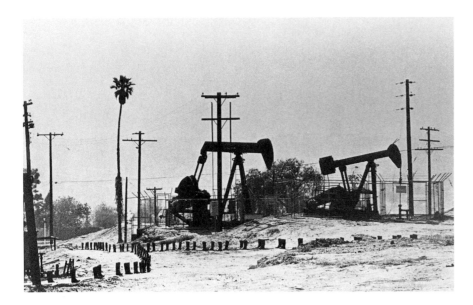

Eleanor Antin. '100 Boots on the Job, Signal Hill, California, Feb. 15, 1972', and '100 Boots Move On, Sorrento Valley, California, June 24, 1972'. Courtesy Ronald Feldman Fine Arts, New York. These photographs were part of a series of fifty-one postcards sent to 1,000 people between 1971 and 1973. A set was later exhibited at the Museum of Modern Art, New York.

people needed protection from. Now nature—tamed, endangered, mortal—needs to be protected from people. When we are afraid, we shoot. But when we are nostalgic, we take pictures.'[6] The NASA photographs hold nothing of nostalgia, nor any fear. We can look at them in the way that, more than a century ago, Englishmen looked at Frith's scenes of Egypt, or Americans at O'Sullivan's and Jackson's views of the Rocky Mountains. They provide, if not a rebuttal, at least a complete contrast to Miss Sontag's rather wearily modern point of view. With this contrast I shall bring this complicated—and I hope challenging—chapter to a close.

# 5. Buying and Selling

There are essentially three ways to buy photographs: from dealers, at auction, and from photographers themselves or their families or estates. Swap meets for collectors also exist, and fairs specializing in 'printed ephemera' should not be shunned—I bought a splendid stereoscopic daguerreotype (neither printed nor, in my opinion, ephemeral) at a fair so titled. These 'meets' and fairs, as well as other more informal networks, tend to be strongest at the lower end of the market. More about them later.

## DEALERS

Harry Lunn, photographed by Fritz Kempe at the Cologne dealers' fair, October 1982.

Photography dealers from Alfred Stieglitz onward have been among the foremost champions of photography as an art form and a collecting field. Lee Witkin, when he opened his first gallery in 1968, cited Stieglitz and Julien Levy as two of his more illustrious predecessors. But Witkin, whose gallery was perhaps the first of the current generation of specialized photography outlets, did not see his initial prospects as specially bright: 'Helen Gee opened her Limelight Gallery/Cafe in Greenwich Village, and with the income from cake and coffee, survived for seven years. There were other attempts in the late 1950s and early 1960s . . . but few of them lasted very long. So in 1968, when I rented my first gallery space . . . my hopes were slight and the prospect of my finally reading all of Proust during the slow hours large.'[1] Witkin, however, hung on and became a major force in the development of the new market, though during the late 1970s and early 1980s he became increasingly disenchanted with what he perceived as market manipulation and price inflation of works which he preferred to sell in larger quantities at lower prices.

The man who in the 1970s brought business techniques to the photography market, and who occasionally was the source of Witkin's dismay, was Washington dealer Harry H. Lunn, Jr. Lunn's first involvement with photography came in 1971 with Ansel Adams's *Portfolio V* which, Lunn said, 'did not do well in New York, but superbly in Washington.'

Lunn's view was, and remains, that in photography 'like any other field the investment advice and the aesthetic practice are the same: try to identify the finest examples by the best artists in the finest possible condition. The rest takes care of itself.' The problem, as Lunn perceived it, was that in the early 1970s too many people believed that all photographs were mass-produced, and that it was therefore necessary for dealers to impose upon the market some kind of edition limitation that would enable collectors to see photographs as comparable with fine prints. Dealers therefore became specialists, as Lunn said at a Kodak Museum symposium in 1977, 'in the creation of rarity.' Lunn had spectacular success in applying his new 'creation of rarity' technique to the work of Ansel Adams, who in 1974 announced that no new orders for prints would be taken after December 1975. Lunn immediately placed so large a print order that Adams was still filling it years after the deadline had passed. By the late 1970s Ansel Adams photographs had become, as Lunn put it, 'a flagship leading the rest of the fleet', and prices for the work of many living photographers, young and old, rose accordingly.

Concurrently, in the New York of the early and mid-1970s, Robert Sobieszek brought an expert eye and considerable historical knowledge to his gallery; Marge Neikrug and Janet Lehr began to include photographs in their gallery inventories, and Scott Elliott's Madison Avenue gallery had a short and tempestuous career mounting shows which many agreed displayed the proprietor's uncanny eye for outstanding images. New York's Light Gallery developed its still-thriving position as the representative of many of the foremost younger photographers, and in London The Photographers' Gallery established itself as the major, and at times the only, venue for British photographers, though its stable of artists is now a highly international one. The Colnaghi exhibition, *Photography: The First Sixty Years*, mounted among high hopes in 1976, was never given a sequel, and various other London galleries came and went, with only Beryl Vosburgh's *Jubilee* and John Jenkins' *Vintage Cameras* (neither of them specializing exclusively in photographic images) steadily flourishing in their chosen off-the-beaten-track venues. Christopher Wood's gallery in Belgravia, though specializing in Victorian paintings, still maintains an interest in photography, and Howard Ricketts, Robert Hershkowitz, Lott and Gerrish, and Ken and Jenny Jacobson, all working from private premises, are also to be numbered among the longest-established photographic dealerships in the London area. In Paris Gerard Lèvy displays, as he has for many years, an almost miraculous flair for discovering superb early photographs—he was a major source for European material in Sam Wagstaff's collection—and the Galerie Texbraun and Galerie Octant have been active and important forces there since the mid-1970s, with the Zabriskie Gallery offering periodic discoveries of major contemporary talent. In Germany Rudolph Kicken became active in the mid-1970s, as did Willem Diepraam in the Netherlands, and in the United States, outside of New York, a number of important dealerships began to be established around the same time, notably Thackrey and Robertson in San Francisco, Stephen White and G. Ray Hawkins in Los Angeles (the latter is now primarily an auctioneer),

Interior of the Thackrey and Robertson Gallery, San Francisco, photographed by Leo Holub. The photographs in the exhibition are by Hill and Adamson.

Tom Halsted in Michigan, and others who have since gone to graze in other pastures.

My overwhelming impression of American dealer activity during this early period was one of confusion. High dealer prices were too often followed by quantities of work by the same photographer turning up at auction at lower prices, and vice versa. As a result a number of collectors, disenchanted by what they saw as sharp practice by both dealers and auctioneers, left the field altogether.

The 1980s have been years of greater sobriety for dealers and collectors, and the establishment of the Association of International Photography Art Dealers (AIPAD) in 1979 has done much to regularize practice among the trade. Many new dealers, some of them highly specialized, have entered the photography market since the late 1970s, and for the most part they have enthusiastically adopted the professional code of the AIPAD charter. The old-timers who are still buying and selling photographs after a decade or more in the business are almost without exception the same dealers who fought for high professional standards. They and their colleagues in AIPAD (which in spite of its title is an almost exclusively American organization) are well worth getting to know. Collectors in other countries will appreciate that different professional organizations exist as well, but the international list of

galleries and dealers appended to this book should give some indication of available sources, though the inclusion or exclusion of a name here by no means implies either recommendation or censure.

## BUYING FROM DEALERS

Many beginning photography collectors are intimidated by the prospect of approaching a dealer for the first time, feeling that it may be difficult to extricate themselves from a gallery or a dealer's private premises without a purchase of some kind (known in the trade as a 'courtesy' purchase). The feeling is natural and is even occasionally encouraged by some dealers, but it should be resisted. A first visit to a dealer should, I believe, be considered a period of grace during which the collector can browse, ask questions, and get to know the dealer and the stock. An honest approach to any dealer, confessing that you are new to the field and outlining your specific interests as far as you know them—you should take prior trouble to make yourself aware of some at least through reading and visiting exhibitions—will almost certainly trigger an interesting and perhaps protracted conversation. Most dealers are, after all, buying and selling because they love their product, and you and the dealer should have something in common. Ask the dealer for a catalogue or price list and take it away with you. If it is well-produced and costs something you will demonstrate your seriousness about the subject, and about the dealer, if you buy it.

You may in general find it difficult to visit dealers' premises without being tempted to buy. Every collector worthy of the name has made mistakes through excess of affection for his objects, and the lessons learned through your own trials and errors will be those best remembered. If a dealer is foolish enough to let you acquire as your first purchase a too-common, over-priced photograph, he can blame only himself if you go elsewhere for subsequent purchases. Most responsible dealers are only too aware of this, and collectors should beware of what Huon Mallalieu calls 'the most serious mistake that the beginner can make', that is 'to assume that all dealers are automatically crooks out to chisel him at every opportunity. Any dealer who does have this attitude to his public is unlikely to stay in business for very long. An actual client must be encouraged to return whenever the fit is on him and his purse permits; a potential client must not be repelled at the first attempt to clamber on board. You must not be put off by the size of a dealer's mark-up if it is justified by the quality of the object. If, for instance, you knew that he had paid a mere £5 for an unrecognized Turner watercolour, and then sold it for £10,000, you should not condemn him for profiteering, but cultivate him as a man of proven professional skill.'[2]

A sensible course to take when contemplating a purchase, especially a first purchase, from a dealer is to canvass his opinion of the object being

considered. You will be surprised at how often a dealer will voice his own reservations as well as enthusiasms, and if you ask, he will usually tell you whether he acquired the photograph at an auction or from another source. Dealers are unlikely to confess whether a 'private' purchase was from another dealer or from an individual or an estate, but this is simply the act of a professional protecting his sources, and should not be taken amiss. What a dealer should be prepared to discuss, and a collector should be prepared to ask, is how far back a particular photograph's history can be traced (this is its 'provenance') and how it compares with other examples in terms of condition and rarity. If it is a twentieth century photograph the dealer should say whether it is a 'vintage' print or a recent one from an earlier negative.

Regarding prices my advice is not to haggle, particularly over a first purchase. Certain tactical approaches are probably acceptable, such as a gentle enquiry as to whether a 'package' price could be offered if more than one work is to be purchased, and certainly if you establish a long-term buying relationship with a dealer there is no reason not to expect some special consideration. Remember as a guideline that the collector who always haggles is unlikely to be the first to be offered a dealer's newest prize acquisition.

As a novice, or even an experienced collector, you may not have the time or the inclination to visit New York and London two or three times a year to attend the major auctions. Similarly you may not want to spend £200 ($300) or so per year to subscribe to the auction catalogues. A dealer in your field can bring to your attention interesting lots coming up at auction, can advise on condition and, for a small commission (usually 10 per cent over the hammer price plus expenses), can purchase, collect, and deliver your photographs to you. Other advantages of using a dealer to execute your auction commissions are that he can inspect lots before the sale and advise you on their condition, and if post-sale problems arise, such as a lot being damaged while on view or after the sale, a dealer is usually better placed to negotiate with the auctioneer than a collector can ever be. Nor should it be disregarded that, if your dealer is a major one in the field, giving him your auction commission eliminates at least one prospective competitor for the lot.

Another bonus that comes from close association with a dealer is getting to learn the trade gossip. If yours is an active and cosmopolitan one he or she will know who has just bought an archive of work by a major photographer, or what dealer bought the particular photograph a year ago at Sotheby's in London that is now being offered at Christie's in New York. This kind of information is enormously useful; it can save you expensive mistakes and put you on the track of wonderful bargains. Your own dealer can also usually negotiate a better price from other dealers than you could, and on a commission purchase of this kind a sensible dealer will try to keep the price as low as possible. Good dealers know that collectors can in time find out other dealers' prices, and they also know that making commission purchases for their private collectors from other dealers' stock gives them a certain status in the trade: all dealers love to have mystery clients unknown to their colleagues.

All that is the good news. The bad news is that at times tensions develop between collectors and their dealers. Collectors sometimes feel that perhaps they have been overcharged, and dealers sometimes suspect collectors of exploiting their expertise only to move on to the greener pastures of other dealers' stocks and the unexplored territory of auction sales. I have known a dealer, infuriated at losing a customer to another dealer, bid enormous sums at auctions to prevent the second dealer buying something for the lost customer. This can become an expensive business all round and can often be avoided through the collector's exercise of a little tact.

Another problem for the new collector is that most dealers have substantial stocks of photographs that nobody seems to want, and the advent of a new customer, any new customer, may encourage the less worthy of them to think they have caught a pigeon. In the final analysis the collector has to judge what photograph is the work of an as-yet-unrecognized genius as distinct from the never-to-be-recognized drudge, or what photograph is simply in such poor condition as to be not worth purchasing at any price. As I have tried over and over again to emphasize, the essential rules for the collector are 'Do your homework' and 'Trust your judgement'.

## AUCTIONS

Every collector of photographs soon discovers that auctions play a powerful role in the market, not only for the simple transformation of goods into cash, but also in subtly establishing 'fair market' prices for photographs about which dealers and collectors might otherwise be uncertain.

Photography at auction is not a new event. At least as early as 1854 the London auctioneers Puttick and Simpson were selling documentary and topographical photographs by James Robertson and Roger Fenton. The date is significant because it was only in the 1850s that photography became sufficiently advanced technically to enable paper photographs to be produced that were not subject to the fading of earlier calotypes.

Later in the 1850s auctioneers handled the bulk of the portfolios of Fenton's Crimean War photographs; Agnew's, who had commissioned them, had failed to consider how strongly the British people would want to forget that war after it was over. When Fenton abandoned photography around 1860 his equipment was also sold at auction, as was William Lake Price's in 1862.

If all this auctioneering activity sounds essentially like estate-clearing, that is exactly what it was. A century later, in New York, Sotheby Parke Bernet was to clear two other major American photographic estates in similar fashion. These were Will Weissberg's and Sidney Strober's, in 1967 and 1970, and the photography market (such as it was) was electrified by prices such as $350 (£145) for a Julia Margaret Cameron portrait in the Weissberg sale, and $5,400 (£2,250) for George Barnard's *Photographic Views of Sherman's Campaign* in the Strober sale. At London

A 'view' at Christie's South Kensington.

book auctions of the mid-1960s such works as Mrs Cameron's *Illustrations of Tennyson's Idylls of the King*, both volumes, had sold for as little as £42 ($118), so it was clear that the new market did better when treated as an artistic entity in itself. In the aftermath of the Strober sale Christie's began to develop photographic sales under the aegis of Christopher Wood, the director of their Victorian paintings department, Sotheby's launched specialized sales in their Belgravia salerooms, and Parke Bernet organized further sales of photographic material in 1971 and 1972, with consignments from a variety of sources.

These London sales were instantaneous successes; the New York sales of 1971 and 1972 were not. In 1974, when I went to New York to re-inaugurate photography sales, I assumed that the New York market in 1972 had simply been unready to support photography sales at the price levels that had been reached during the Strober sale. Later it became clear to me, with hindsight, that the Cameron price in the Weissberg sale and the Barnard price in the Strober sale had been the harbingers of an entirely new market for photography, to put it bluntly, a put-it-in-a-frame-and-hang-it-on-the-wall market. Philippe Garner, in London, who from the outset was responsible for Sotheby's photographic sales, brought an artistic eye to his subject, and as of this writing still combines under his directorial aegis Sotheby's Art Nouveau and Art Deco department as well as photographic sales. His vision of what was then a new market is reflected in the magnificent photographs from his early sales which he had the foresight to reproduce in colour, and which appear here in all their splendour through his, and Sotheby's, courtesy.

My own artistic training was non-existent. I originally brought an historian's perspective to the photography market, a perspective in which, as events proved, the market was not especially interested.

The first sale I organized in New York was held in February 1975. It was divided into two sessions, the first mostly nineteenth century, the second almost entirely twentieth century. It proved to be a seminal sale in a way that I did not expect: it began the involvement of photography dealers as major auction consignors, an involvement which succeeding years have shown to be long-term. Much of the nineteenth-century dealer-consigned material in this auction failed to sell—was 'bought in' as the auctioneers say—and its failure reflected the same lack of interest in purely historical photographs that the unsuccessful 1971 and 1972 sales had demonstrated. The twentieth-century session, however, was a runaway success. A large format photogravure of Alfred Stieglitz' *The Steerage* set what was then an auction record for a twentieth-century photograph—$4,500 (£2,368)—and the high prices across the board of other twentieth-century material displayed the readiness of the American market to accept photography as art.

The fact that much of this 1975 sale had been consigned by dealers was no secret: the Washington *Post* of 26 February 1975 reported that the photographs that Harry Lunn, of Washington, had 'placed upon the block fetched . . . $30,000 (£15,789).' What Lunn and others recognized was that the market even for twentieth-century 'art' photographs was thin; that is to say, there were at that time too many photographs chasing

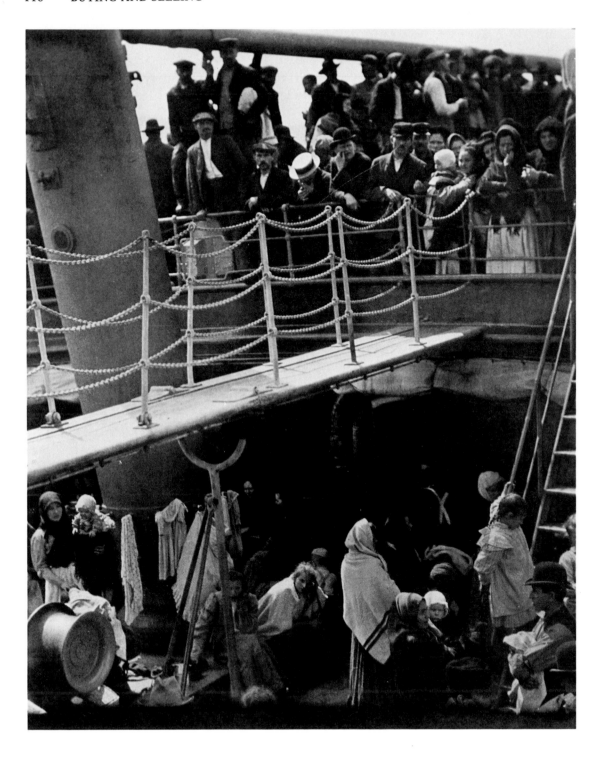

Alfred Stieglitz. 'The Steerage', large format photogravure from *291*, 1915.

too few buyers. Auctions were perceived as providing a foundation for a price structure that could be seen as both legitimate and reliable, and thus an encouragement to new collectors to enter the field. Auctions were also a useful outlet for dealers and consortiums who had bought archives or estates of photographic material which needed careful long-term dispersal. Two good examples of such archives were those of Heinrich Kuehn, the German Photo-Secessionist, and the American photographer Walker Evans; these archives are still being dispersed, and market-watchers have noticed the steady rise in prices for the best of the work of both these photographers.

In England in the 1970s, however, consignments to the London auction rooms, especially Christie's and Sotheby's, were overwhelmingly drawn from private accumulations and English country-house attics. The dramatic increase in auction prices for the work of British nineteenth-century photographers ensured a steady supply of this material throughout the 1970s. At the *Rencontres Internationales de la Photographie* at Arles in 1977 I described this phenomenon in the following terms:

> The London auction houses, Christie's and Sotheby's, were well placed to receive this new material. Both houses had been in business over two hundred years and since nineteenth century photography was largely a pastime, both collecting and practising, of the aristocracy, their long-standing connections with English families meant that as country houses were cleared, photographs and albums found their way to auction. It was also important, in a new collecting field where prices were uncertain, that the London auctioneers acted as agents only. . . . The principle of agency in the auction houses, where the auctioneer's earnings increased in proportion to the amount he earned for his consignor, proved to be an important one in the growth of the London photography auctions, as it had with other fields in the past.

It was also true in London that there could be tax advantages in selling large accumulations of photographs a few at a time over a period of several years. The near-veneration in which the London salerooms were held meant that Sotheby's could slowly disperse an important Julia Margaret Cameron collection, and Christie's perhaps the single most important archive of Roger Fenton discovered to date.

One significant difference between photography and other more traditional collecting fields still obtains in the market-place, in spite of more than a decade of regular photographic auctions. In older collecting fields—books, paintings, porcelain—there is a group of long-established dealers with stocks of material going back some decades. The basic price structure is established; one knows where Dürers and Van Goghs are and what sort of price range they are in, as one does with Sèvres porcelain and sixteenth-century books. There are always surprises in the salerooms, but except at the most expensive end of the market there are dealers consistently buying to replenish their stock, and in many cases dealers will bid and buy up to a certain price simply to support the basis

of their own price structure, knowing that if necessary purchases can be put aside for a few years until retail prices catch up with them. This is only gradually becoming true with photography, where a dealer established for more than a decade is a rarity, and it means that the auction market in photography is still not 'firm' in the traditional sense. It remains largely an individual collector's market, in which prices can be low if current collectors have what is offered, then rise again when new collectors appear on the scene.

## BUYING AT AUCTION

Bidding and buying at auction can be a complicated business, and a risky one for the newcomer to the market. Huon Mallalieu in *How to Buy Pictures*, a companion volume to this one, has written of the adversarial nature of the procedure: 'Perhaps the strongest draw of the auction is that with judgement, hard work and luck anyone may be able to snatch something glorious from under the noses of the enemy: and while we are actually bidding everybody else is the enemy—dealers, fellow collectors, ignorant and innocent-seeming passers-by, and above all that charming and so helpful wielder of the hammer on the rostrum, whose job it is to make us pay the highest possible price.'[3]

The essential pre-requisite for going to an auction is the auctioneer's catalogue. These are normally available about a month in advance of the sale. Making sense of the descriptions is normally quite straightforward; photography cataloguing contains little of the jargon of say, book and print catalogues. But there is one problem: photography auction catalogues give virtually no indication of the condition of a print. Take, for example, this lot description from a recent Christie's South Kensington sale:

CHARLES CLIFFORD (d. 1863)
and BISSON FRÈRES

**Two Spanish architectural studies and construction detail, Louvre**

Three albumen prints, the former approx. $16 \times 12\frac{1}{2}$ inches, the latter $18 \times 13\frac{3}{4}$ inches, each mounted on card, mounts trimmed, the two former with blind-stamp 'C. Clifford, Photo of H.M.', the latter with photographers' facsimile signature on image and blindstamp 'Bisson Frères, Editeurs à Paris, R. Carancière 8' on mount, late 1850s.                                                          (3)

'Mounts trimmed' provides the first warning, since mounts are usually trimmed so that photographs will fit into frames. Once framed, photographs are exposed to light and start to fade. These, clearly, are faded indeed, since the auctioneer has lumped the three into one lot, and has not provided a specific estimate, thereby indicating that the lot is not expected to fetch as much as £100 ($150). Yet an unwary bidder might

Lillian Fischer, fashion editor of *Harper's Bazaar,* photographed by Jean Moral in Paris, c.1930. Models often have wonderful collections of fashion photographs, inevitably by both major and minor photographers. Miss Fischer's collection, formed during the 1920s and 1930s, included vintage photographs of her by Arnold Genthe, Man Ray, Edward Steichen, and Baron de Meyer. it was dispersed at Sotheby's New York during the 1970s, and attracted fierce competition in the saleroom.

think this a wonderful opportunity to acquire three photographs by two of the major architectural photographers of the decade. Far from it. . .

Even where an effort is made to describe condition and, occasionally, rarity, these can prove to be vexed questions, the auctioneer's opinion differing from that of the purchasing audience. In a recent dispersal of Paul Outerbridge photographs in New York prints were described in some cases as 'unique' or as 'one of two existing prints.' It is probably safe to say that if additional prints were to emerge the fact of their existence would not enable the auction sale to be rescinded; the auctioneer would argue that the catalogue was prepared in good faith and in the light of information available at the time. Nevertheless the prices for many of these Outerbridge photographs were enormous.

Anyone attending a photography auction is likely to be soon aware how often prices for fine privately-consigned photographs can, through fiercely competitive bidding, skyrocket. But there can also be another dimension to what Huon Mallalieu calls an auction's 'adversarial relationship': a photograph under the auctioneer's hammer may be the property of a dealer sitting in that very auction room. There is nothing improper in this, unless the dealer starts to bid on his own property, which is illegal if a reserve price has been previously agreed. If you are a collector attending the auction you may want to ask yourself—in fact you definitely *should* be asking yourself—where the photographs in the auction have come from. The best private consignments will be identified; private collections, especially old ones, have a powerful cachet which raises prices. Among the 'other properties' in a sale, however, will lurk a great many dealers' offerings, in American salerooms especially but increasingly in London too. If you do your homework you may be able to identify the sources of some of these properties. Once they are identified you are left with the straightforward question: 'Could I buy the photograph from the dealer himself for less?' The answer is not always clear; there may, after all, not be another print from the same negative available in the retail trade, yet nothing is more frustrating than the discovery after an auction that a photograph you have just bought is available at retail for less than you have just paid for it. But you should avoid the easy cynicism I have sometimes seen at photography auctions, whereby collectors assume virtually everything to have been consigned by dealers and argue that everything from a dealer should be shunned. Often a dealer's purchase of an archive means cash-flow difficulties, and as a result some of the best of the purchase will be offered at auction to raise cash and establish up-to-date market prices. The cynical 'in the know' buyer who ignores this opportunity may find later that the only possible acquisitions remaining are less desirable photographs—at higher prices.

## COLLECTORS' FAIRS AND EXHIBITIONS

Many collectors prefer the informality of collectors' fairs, 'swap meets, and amateur shows to what they perceive as the high-pressure selling

atmosphere of specialized dealers' premises and auctions. The less formal venues tend to specialize in stereo cards and apparatus, architectural, travel and portrait albums, and single daguerreotypes, ambrotypes and cartes-de-visite. Larger-format single photographs by well-known photographers are seldom to be seen, though of course any that do turn up can be bargains. Much of the fun of these informal fairs is in meeting kindred spirits, and photographic and other antiques publications usually contain schedules of them and of other more general antique fairs.

## SELLING

Sooner or later every collector comes to think about selling. For some it is a matter of upgrading their collections, or purchasing a photograph which can be afforded only by selling a less prized object. Other collectors lose interest in a specific field, or in collecting altogether. Still others enjoy the challenge of trying to sell at a profit in order to make their collection self-financing. Some collectors in this last category annoy full-time dealers by trying to claim trade privileges and discounts; in America they usually acquire 'resale permits'. Such collector-dealers, whose primary income derives from other sources, are likely to find themselves ignored when the real plums are offered for sale to favoured customers.

The vendor, whether of a single photograph or a collection, has essentially two choices, dealers or auctions. In the United States well-to-do collectors may find there are considerable tax advantages to be had from donating their collections to institutions; this alternative requires expert advice outside the scope of such a book as this.

Although dealers are likely to be interested in purchasing exceptional single photographs and collections assembled over a long period and therefore fresh to the market, this is the very material that is likely to attract the fiercest competition if offered for sale at auction. As a rule dealers are less keen to buy back material they have only recently sold. In most collecting fields the rule is that a purchase from a dealer today is likely to attract an offer of no more than about 60 per cent of the buying price if sold back to the same dealer tomorrow; Tennyson Schad suggests that with photographs the material 'would have to have extraordinary intrinsic value and marketability for a dealer to be willing to pay as much as 50 per cent of current retail price, and then will probably want to pay you over a period of time if a substantial amount of money is involved.'[4] At auctions the same kind of price disparity often applies when recently formed collections are offered for sale, which is why undiscriminating investors out to make a quick profit so often come to grief. Recently purchased photographs consigned to an auction are almost always recognized by the dealers who sold them in the first place. They know what the collector originally paid, and the auctioneer's estimates will reflect the collector's selling expectations. When these are high dealers often simply decline to bid, and unless there is a substantial

influx of new collectors to the market the photographs will be 'bought in' and returned to the collector, often with a bill for the auctioneer's expenses.

Serious collectors who have established good relations with a dealer will sometimes find that he will accept for full credit a photograph recently sold, provided that the collector is making a larger purchase. This is not, strictly speaking, profitable for the collector, but it is, after all, the dealer who relies on sales for a livelihood, and by taking back a photograph at its original retail price the dealer is almost certainly giving the collector more for it than he would realize elsewhere. Another way of selling through a dealer is to place photographs on consignment, the dealer taking an agreed percentage of the selling price. A consignment arrangement will usually realize more money for the vendor in the end, but it takes more time. You should also remember that if the dealer with whom photographs are placed on consignment has other work by the same photographers his own examples are likely to get preference when the time comes for a sale.

If you decide to sell your photographs by consigning them to a dealer or an auction house be sure to get a detailed receipt for them, with agreed valuations. Make sure they are also covered by the dealer's or auctioneer's insurance and read the terms of the insurance coverage. Photographs are more likely to be damaged at an auctioneer's exhibition than at a dealer's premises, but in either case it is better to be safe than sorry.

One of the mistakes consignors to auctions often make is assuming that an auctioneer's estimate bears a definitive relation to the actual sum finally received. If you leave your collection with a dealer and agree prices in advance, the dealer will either sell your photographs at the agreed prices or not at all. If, however, you take your photographs to an auctioneer, it is not the estimates that count, but the agreed 'reserves', the prices below which the photographs will not be sold. Since 'reserves' will not in general be higher than the auctioneer's estimates experienced auction buyers normally look only at estimates to see whether the consignor is being over-optimistic. Remember that the auctioneer who estimates 1,000-1,500 pounds or dollars rather than, say, 700-1,000 for a particular photograph will still sell it for 500 if that is the only bid and no reserve has been fixed. Most auctioneers are likely to be fairly realistic about reserve prices; they earn their living by selling things, not by buying them back, and the auctioneer who gives you the most expert advice is very likely the one who will have managed to acquire the best company for your photographs to keep in a sale. Such intangibles—what the photographs either side of your consignment are like, how the stock market has performed recently, even the kind of lunch the collectors and dealers have just eaten—can affect prices. Always place reserves on your photographs if the auctioneer will accept them, but if you genuinely want to sell listen to the auctioneer's advice and don't be greedy. If your reserves are too high, they may be reflected in too-high auctioneer's estimates, and high estimates are powerful deterrents to spirited bidding. If the auctioneer is pessimistic about the chances of your property selling,

remember that a dealer will make an offer for your photographs without charging you anything and without subjecting them to the wear and tear of a public view. An auctioneer's bill for an unsold consignment will often include such things as catalogue illustrations and insurance—the total expenses can sometimes run to hundreds of pounds (or dollars) or more.

Of course the romance of selling at auction, and the possibility of an enormous price being paid for something on which an initially low valuation has been placed, are strong temptations. But specialized objects can sometimes bring heart-breakingly low prices at auction through lack of competition, and in such cases a vendor is much better advised to sell to the specialist dealer directly—provided the right specialist can be found. Your own dealer may be prepared to offer dis-interested advice, which is well worth acting upon, or try one of the professional dealers' associations, like AIPAD. However much sentiment was involved with acquiring all the to-you-irresistible objects in your collection, it is wise to remember that selling is a business and is best approached with as hard a head as possible.

# 6. Collecting Pitfalls: Some Cautionary Tales

My introduction to the complex problem of forgeries and frauds in photography came in 1974, when I uttered, all unwitting, what proved to be a prophecy. The National Portrait Gallery had mounted a show called *The Camera and Dr Barnardo*, and I, on my way to take up responsibility for photographic sales at Sotheby's in New York, naturally went along. I thought the show was for the most part disappointing, except for some salt prints of young girls described, I recall, as Victorian child prostitutes. These had an extraordinary impact; I said to a friend that I thought they were almost too good to be true.

These photographs, described in the exhibition as the work of one Francis Hetling, otherwise unknown, were to drift in and out of my awareness for the next several years. During that time I, along with many in the photographic community, came to regard these 'Hetlings' as fakes, as an elaborate hoax played on all of us in the photography 'establishment' and, as the National Portrait Gallery show seemed to demonstrate, a lesson to the unwary. I think someone told me two or three years later that the photographs had been taken by an advertising photographer named Howard Grey, whose work I knew from a wonderful spoof he had done of Julia Margaret Cameron by photographing a modern collector costumed as Lancelot in Tennyson's *Idylls of the King*.

The 'Hetlings' were exposed as fakes in a London *Sunday Times* article on 19 November 1978. Philippe Garner, of Sotheby's, had some 'Hetlings' in his collection, and the same newspaper later stated that with these 'Garner was himself spoofed. When Grey told him at a dinner party that his "Hetlings" were not genuine, he moved them from his nineteenth century collection to his twentieth century collection.'[1] The issues at stake then, as now, involved the entire credibility of the photography market. What photography in the late 1970s was waking up to, as the press over and over again emphasized, was that in a field where single prints were selling, in 1980, for up to $30,000 (£13,636), the market was going to attract, if it had not already attracted, fakers out for financial gain.

The 'Hetling' photographs provide a useful microcosm of the problem of fakes, but it is worthwhile differentiating the problems of faking *per se*

The impossible pose.

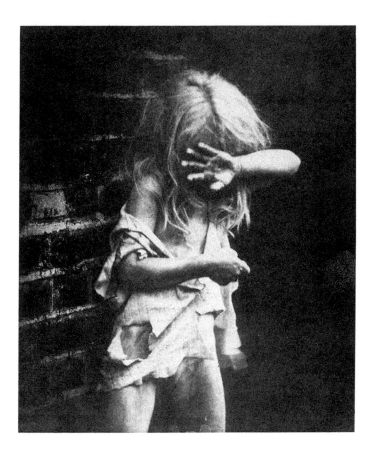

Opposite  A 'Hetling', taken 'under the railway arches'. This is one of the photographs I remember seeing at *The Camera and Dr Barnardo* exhibition in 1974.

from a related problem which resulted in a long London court case in 1980. At the heart of both was an artist, Graham Ovenden, co-founder of the 'Brotherhood of Ruralists' school of painters. During the London trial Ovenden did not deny creating salt prints from photographs taken by Howard Grey, and told the court he had conjured the name Francis Hetling 'out of the air.'[2] He said that he had wanted to prove 'that living photography is a fine thing, not only when it entails age',[3] and his knowledge of Victorian photography and its market were such that he could readily produce a convincing photographic prototype. The court case, however, also involved a charge that Ovenden had made money by selling some 'Hetlings' to a London collector knowing them to be fakes; on this charge no verdict was ever reached.

Grey's 'Hetling' photographs are compelling indeed, showing eleven-year-old girls dressed in rags and photographed, as the newspapers said, 'under the railway arches at King's Cross.'[4] What were the steps involved from Grey's modern negatives to the finished, apparently Victorian, calotypes? I am not sure whether a paper negative was created or not, but the rest of the technology would have been comparatively simple. The 'Hetlings' are on old paper—I have seen one with the paper watermarked 1835—and once this kind of paper is impregnated with the appropriate chemicals required for producing a calotype, there is little

that can be done to prove chemical fakery short of an exhaustive comparative analysis to identify trace elements present in Victorian chemicals but absent in modern ones. In fact, though early calotypes were printed from contact with a paper negative, there is no reason why Ovenden's 'Hetlings' could not have been printed from a small negative via an enlarger. The important step would have been the impregnation of the old paper with the right chemicals; once printed the photographs could then be trimmed, as the 'Hetlings' are, to remove any undeveloped edges.

As for the subject matter of the 'Hetlings', however, one look at the photograph illustrated here should ring alarm bells in the viewer's mind. Why does the girl have her hand over her face? Out of shame for her depraved life and to protect her identity from the camera? But the notion of the intrusive photographer is a modern one, unknown to early photography, and this apparent modernity in the 'Hetling' leads by deduction to even more conclusive doubts of its authenticity. Part of the photograph's impact derives from the appearance of the little girl's flinging her hands up as if to protect herself, but to get this effect in an 1840s or 50s calotype the pose would have to be held for at least two or three minutes, quite an improbable feat for a young street urchin. A closer look at this photograph also reveals a too-great resolution of detail for an 1840s calotype, while I for one am now suspicious of a too-rich 'purply-pink' colour in calotypes, though on neither of these features would one be

Photogenic drawings by their very nature make an attractive target for the would-be forger. This one, reproduced courtesy of Hans P. Kraus, Jr., has an impeccable pedigree: the Whatman 1838 watermark in the paper, and an identification, date (April 1839) and signature of the photographer, W.H.F. Talbot, himself. Needless to say not every photogenic drawing will have all these ideal features, and the past history of the print, as with any photograph, should as far as possible be verified.

likely to brood unless suspicions had already been aroused. The discovery in 1978 that the National Portrait Gallery show 'Hetlings' were fakes, however, was not based on the photographs themselves but on the fact that one of the models was recognized by a friend of the family as alive, well-fed, and living respectably in Twickenham! The rest of us cannot always expect to be so lucky if confronted by a fake, but the important thing to remember is always to heed your instincts. If something looks or even somehow 'smells' the slightest bit wrong, start asking questions. Provenance, technique, documentation, all these are legitimate subjects of enquiry of anyone offering works of art for sale.

A journalist remarked after the 'Hetlings' exposé that 'many will be in sympathy with the desire to hoodwink establishment authorities'[5] and the case was taken a step further when *Connoisseur* magazine commissioned none other than Howard Grey to collaborate on the production of 'Victorian' calotypes in 1981 for an article by Isabelle Anscombe about 'fooling the experts'. Fool them they did. Two portraits of Miss Anscombe, and a still life of ivy were produced, printed on nineteenth-century paper, and shown around London. According to *The Times* the Victoria and Albert Museum said the photographs 'would make a welcome addition to their collection', the National Portrait Gallery 'expressed distress at not recognizing the "aristocratic" features of the woman in one portrait', Christie's South Kensington said 'very interesting and worth about £400 to £600 ($840-1,260)', and Sotheby's Belgravia '£30 to £50 ($63-110), but more if the photographer could be identified'. A London dealer suggested the photographs were salt prints from a glass negative 'dating perhaps from 1855 to 1857. He offered £150 ($330) for the two portraits.'[6] As Isabelle Anscombe wrote in her article, 'There is no historical photographic process which cannot be duplicated today. If paper torn from the fly-leaves of Victorian books is used, it is possible to make salt prints or albumen prints which are chemically indistinguishable from genuine Victorian prints. The detection of fakes rests only with the interpretation of the photographic qualities of the image, by reference to what was photographically possible at any given time.'[7] As I indicated earlier in this chapter, I do not altogether accept that modern salt prints are entirely 'chemically indistinguishable', but if, reading all this, you begin to despair of ever being able to collect early photographs with confidence, the next case I shall describe will deepen that despair. In 1976, when I took over sales of photographs at Christie's South Kensington, I inherited a consignment from an elegantly named Lancastrian, one George Bernard Shaw. This consignment consisted of 'photogenic drawings': impressions of leaves, ferns and the like on sensitized paper, a technique developed by Fox Talbot. Subsequently Mr George Bernard Shaw consigned daguerreotypes, more photogenic drawings, and finally some 'Hill and Adamson' salt prints. Some of these he said he was delivering for a friend, and a consignment slip was filled out. I sent it to Lancaster for authorization to sell, and it was duly returned with the 'consignor's' signature, who subsequently turned out to be the dog mascot of an Oldham beauty salon. To me the 'Hill and Adamsons' appeared to be the crudest possible forgeries, and, though I believe some

of the consignor's material to have been genuine, all of his property was withdrawn from sale and Christie's dealings with him were terminated. This odd story subsequently became public, inasmuch as I was called as a witness at Manchester Crown Court when George Bernard Shaw was indicted, and ultimately convicted, on a charge of selling a faked daguerreotype to the North Western Museum of Science and Industry.

Mr George Bernard Shaw's fake daguerreotype was supposed to have been a telescopic view of the moon—and herein lies another problem for the collector: if a forger has access to early photographs there is nothing to keep him from, say, making a daguerreotype of another photograph. A large albumen print of, for example, an American covered-wagon, or an Egyptian pyramid, if photographed with a daguerreotype camera, carefully developed and inserted in a genuine daguerreotype case, is likely to fool, and may already have fooled, some experts. Very careful inspection of the daguerreotype should reveal the paper grain of the original print, though this sort of inspection requires an expert eye. But it is surely time for photography to begin to rely more upon its experts. Repainting of damaged sections of canvas in paintings, sophistication via facsimile of rare books, and states of rare prints all require expert judgement and analysis, and all substantially affect prices. There is nothing a forger can create which an expert cannot detect, but the better the forger the better the expert required, hence the emphasis in earlier chapters on the importance to the collector of developing relationships in the trade and with curators.

There is one final area in photography collecting about which cautionary notes should be sounded, an area which in time may evolve beyond the detective skills of the best experts, and that is the so-called 'intensification' of photographic images. Many, if not most, calotypes and albumen prints are faded to some degree, calotypes usually the more severely. Indeed a contemporary cartoon satirizing Talbot's process showed a calotype print in three stages: 'Going, going, gone.' But recent chemical experiments by restorers have produced a process whereby fading can be reversed and the image, for all practical purposes, re-developed, fixed and washed as if for the first time. Although some experts believe that with experience these intensified early photographs may be identified—Stephen White in Los Angeles speaks of a certain 'murkiness' in an intensified image—others disagree, citing the enormous variations present in unrestored examples of early photographic processes. Argument over the merits of these restorative techniques is, needless to say, intense. Responsible dealers and curators argue, quite rightly, that there is no way of gauging the long-term effects of the processes and that a respectable, if somewhat pale, calotype, intensified, may at some stage fade entirely or blotch irremediably. Indeed the Association of International Photography Art Dealers issued a statement in April 1985 unequivocally condemning the use of intensification processes: 'The Board of Directors . . . is opposed to the use or commission of any intensification techniques by conservators, dealers, collectors or curators. AIPAD is resolved that its members will not commission the use of these methods nor knowingly sell any prints that have been inten-

*Opposite* Julia Margaret Cameron. 'The Dream', study of Mary Hillier, albumen print, 1869, on the original mount with the photographer's copyright notice, signature, and date. Compare the lustre of this print, which sold at Christie's South Kensington in 1985 for £1,300 ($1,560), with the pallor of the Carlisle portrait by the same photographer illustrated on page 9. With Cameron photographs, and others which appear on photographer's or publisher's mounts, the condition of the mount often gives a clue to what the photograph should look like. A rich, immaculate photograph on a bedraggled mount should give cause for suspicion.

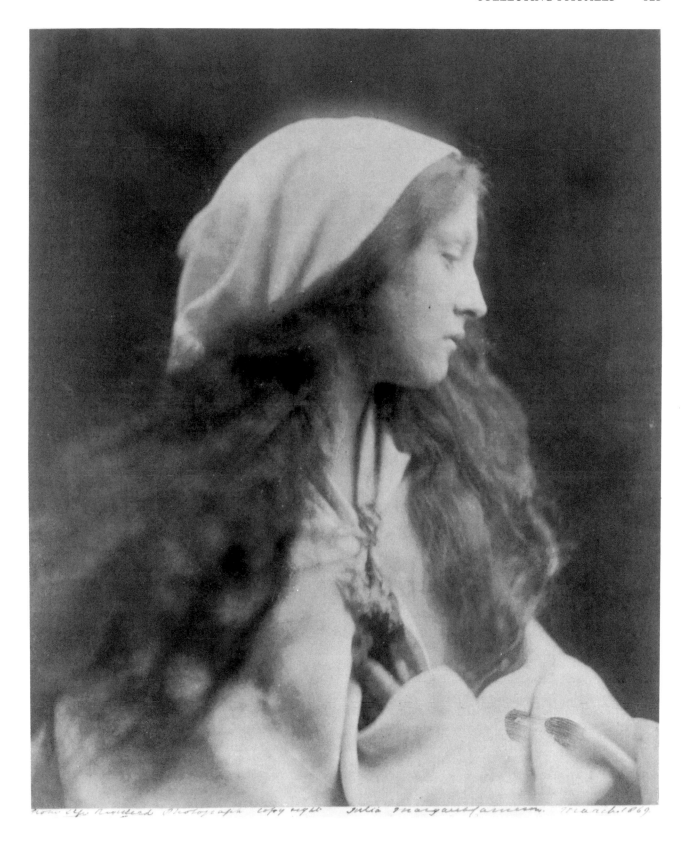

photographs. Other colour prints should be treated like salt prints: never hung, and protected from light as much as possible.

## STORAGE AND CONSERVATION

Many collectors find the urge to tinker irresistible. With photographs it is essential to resist. The damage that can be caused is incalculable and can be irremediable. I have heard of a museum whose photographer unhesitatingly broke the seal on a daguerreotype, removed the copper plate and set a piece of glass on it in order to get what he thought would be the best possible photograph for the museum's archives. The daguerreotype was so badly scratched as a result that the image is now all-but-invisible. Other horror stories abound, and my sole and fervent recommendation is that you save your tinkering impulses for the construction of storage, and take your conservation questions—even on a matter as small, as, say, removing a crease from a paper photograph—to a qualified conservator.

Many curators recommend that photographs should be individually stored in acid-free surroundings. Mary-Anne Morris, formerly Assistant Conservator at the Getty Museum, suggests that 'handling mounts' should be made for photographs and stored in drop-back or solander cases. 'Handling mounts should be made of all-rag museum board, which is acid free and should be unbuffered, that is without any added alkaline content. Mounting hinges should be of japanese paper and wheat starch paste. Cases should also be made with archival materials.' Miss Morris also believes that 'everything should be window-mounted to relieve wear-and-tear on the image, and a sheet of glassine over the image provides further protection.'[1] Some collectors prefer their images to be 'free-floating', that is with all the photograph's edges visible; others prefer over-mounting.

The best thing to do with daguerreotypes and ambrotypes is to leave them alone. Some ambrotypes which have had the backs of the images painted black to reverse the polarities, need expert restoration of the black coating; this too should be referred to a conservator, though Miss Morris would allow collectors themselves to replace the black velvet backings that come with some ambrotypes and are subject to fading.

Finally it is worth noting briefly what kind of work collectors can expect from conservators. According to Miss Morris, 'conservators as a professional body do not support the use of chemical techniques', which in theory means that no responsible conservator will ever attempt the intensification of an image on your behalf, nor will a conservator use chemical cleaners or solvents on a photographic image. But the state of the art concerning paper repair is quite advanced, and remarkable results can be obtained from the dry-cleaning and repairing techniques which are a conservator's stock-in-trade. In general this book has emphasized that the collector should aim to acquire photographs in the finest condition possible; but on the occasion when none but the torn and dirty is available the conservator can prove a friend indeed.

# Technical Glossary

The technical distinctions between kinds of photographs can be confusing, but understanding them is essential for the collector and can sometimes save expensive mistakes.

During the first two or three decades of commercial photography two entirely different processes co-existed. Nicephore Niepce, who produced the first successful photograph in 1826, had his work carried on by L.J.M. Daguerre, who, tradition has it, made a great leap towards perfecting his process by accidentally spilling a jar of mercury near some exposed photographic plates; the mercury fumes caused the latent images to become visible. The daguerreotype, as it came to be called, was a direct positive image: the plate in the camera became the finished photograph, and thus was a unique and unrepeatable object. The calotype process as invented by Fox Talbot in England and Hippolyte Bayard in France involved producing a paper negative from which any number of positives could then be contact-printed. The two processes co-existed for a number of years, vying for custom, and the practitioners of both sought the ideal method of producing images that could be mass-produced in books. But the ultimate domination of the negative-positive process was a foregone conclusion, and since this process has now dominated photography for more than a century it will inevitably be the object of most collectors' attention.

I have sub-divided photographic processes into three sub-headings: positives on metal and glass, negative-positive paper processes, and photographic printing techniques. To allow the collector to focus his attention as he wishes I have, as far as possible, listed the various processes under these headings in chronological order. The lists are not intended to be comprehensive, but will, I think, cover most processes a collector is likely to encounter. The esoteric-minded should skip immediately to the Further Reading section of this book, and get hold of one of the histories like Helmut Gernsheim's, which gives full details of the various processes and their arcane offshoots.

Nicéphore Niepce. Cardinal Amboise, heliogravure from an engraving. The pewter heliographic plate made by Niepce was used by the curator of the Chalon Museum, Jules Chevrier, to make a few prints in 1864, of which this is one example. Chevrier has pencilled a note on this print, stating that the plate was the 'Premier résultat Heliographique'. The print sold at Sotheby's London in 1982 for £3,200 ($5,760).

## PHOTOGRAPHIC POSITIVES

1 **Heliograph:** Niepce's original process, literally meaning 'sun-written'. It involved coating either glass or metal with oil of lavender saturated with colouring of bitumen of Judea. This coating hardened where struck by light, and the unhardened parts were washed away with petroleum solvent. The process was enormously lengthy (bitumen of Judea is a kind of asphalt which, not surprisingly, takes a long time to harden), and Niepce's first successful photograph, taken in 1826, had to be exposed all day.

This rare survival of an exposed daguerreotype plate shows how the multiple exposures were made. It may be that this plate was improperly inserted in the camera, causing the images to overlap, and so was discarded in its entirety after it became clear that it could not be satisfactorily divided. Oddity that it was, it brought £280 ($588) at a Christie's South Kensington sale in 1981; a single quarter-plate daguerreotype in such condition would have been valueless.

2 **Daguerreotype:** a considerable sophistication of Niepce's process. Daguerre's invention became the first commercially practicable photographic process, published in 1839 and in widespread use within a year. Immediately identifiable by its mirror-like shine, the production of a daguerreotype involved coating a polished copper sheet with a light-sensitive substance called silver halide. Development occurred by exposing the plate to mercury fumes, which left a deposit in proportion to the degree of a given area's exposure to light—lighter areas had more mercury, darker areas little or none. Most daguerreotypists—and there seem to have been thousands—used cameras that took plates measuring $6\frac{1}{2} \times 8\frac{1}{2}$ in. The plates were normally exposed one-sixth at a time, allowing a portrait sitter more than one pose, or for the photographer to keep prices down by getting six subjects on one plate. Thus the most common daguerreotype size is 'sixth plate' ($2\frac{3}{4} \times 3\frac{1}{4}$ in.), but sizes as small as sixteenth plate ($1\frac{5}{8} \times 2\frac{1}{8}$ in.) are regularly seen. Less common are the half and whole plate sizes ($4\frac{1}{4} \times 6\frac{1}{2}$ and $6\frac{1}{2} \times 8\frac{1}{2}$ in. respectively) which were more expensive to produce, and rare indeed is the beast known as the 'double whole plate': $8\frac{1}{2} \times 13$ in. Cases for daguerreotypes are often very elaborate, made either of embossed leather or moulded papiermaché, with interiors of plush velvet and polished copper.

*Opposite left and right* Two particularly attractive daguerreotype cases. The portrait of Daguerre is gilt-embossed on a leather case. The other, depicting the Washington Monument in Virginia, is of moulded 'thermoplastic'.

3 **Ambrotype:** something of an anomaly in the world of photography, the ambrotype owes its existence to the enormous popularity of the daguerreotype. The process used for making ambrotypes was invented in 1851, and is precisely the same as for making an albumen glass negative (for which see below), but instead of printing from the glass negative, the photographer backed it with black paper or metal (or simply painted the back black) in order to reverse the image from negative to positive. The glass plate was then mounted in a daguerreotype case. It could be produced and sold for considerably less than a daguerreotype—not surprising considering the relative expense of copper plates, silver and mercury compared with glass plates and egg albumen. Ambrotypes came in the same sizes as daguerreotypes, and, because they used the same kinds of cases the two are often confused. Do *not* take the case apart to investigate; a much easier check is to tilt the image in its case so that it catches light at different angles. A daguerreotype will reflect light, the image sometimes seeming to shift from positive to negative, sometimes disappearing altogether. Ambrotypes, rather unromantically, look much the same from any angle.

4 **Tintype or ferrotype:** a sophistication of the ambrotype in which the photographic collodion was coated onto a sheet of black iron or tin to produce a direct positive image. Patented in the United States in 1856, the process became associated with portraits of American Civil War soldiers, their families and sweethearts, and stories were told of the bullet-stopping qualities of the tintype in the breast pocket. Tintypes often turn up unmounted, as they have a tough and durable surface, but when cased like ambrotypes the two processes can be difficult to distinguish—watch for the duller, less contrasting surface of the tintype, and ripples in the surface of the tin plate. The dull tintype surface contrasts even more dramatically with the mirror-like shine of a daguerreotype, and if you are foolish enough to take a daguerreotype out of its case you will soon find out how much less durable its silvery surface is than the tough albumen coating of a tintype.

5 **Lantern slide:** not really a special technical process at all, but a late nineteenth-century development consisting of a photographic positive printed on clear glass, enabling the image to be projected onto a screen. Lantern slides, in my experience, have usually been of mediocre quality, and as a collecting field have inspired little enthusiasm. They are difficult to look at properly, and in quantity are heavy and easily broken.

6 **Autochrome:** the first successful colour photographic process, producing a positive transparency on glass, cumbersome and fragile but often of an exquisite beauty. The process was patented by the Lumière Brothers in France in 1904. Coloured starch grains on a sensitized glass plate were used to filter the light which exposed the photographic emulsion, then processed to create an image consisting of tiny specks of colour. Many fine art photographers experimented with the process, including the Photo-Secessionists, who reproduced some of their autochrome studies in *Camera Work* XXII. Unlike most lantern slides, autochromes almost always repay the technical bother of looking at them.

*Opposite* An unusual, outdoor half-plate ambrotype, probably late 1850s. The eucalyptus trees in the background suggest either a Western American or, conceivably, an Australian origin.

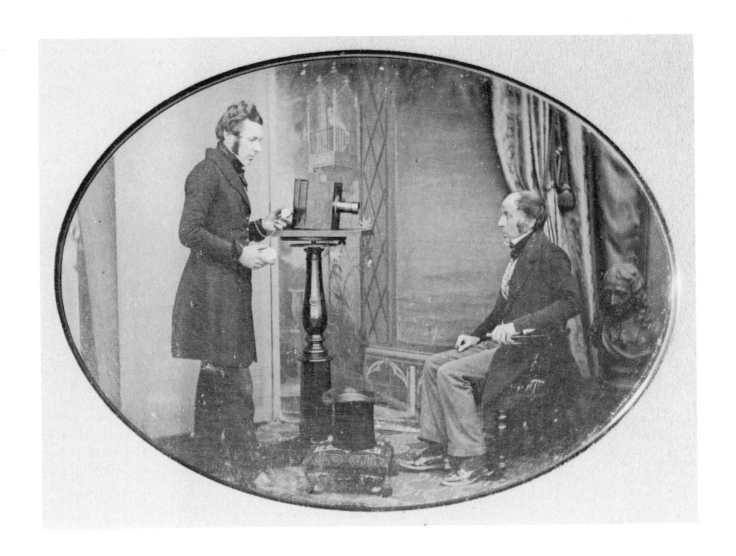

'Jabez Hogg and Mr Johnson', quarter-plate daguerreotype taken in Richard Beard's studio prior to August 1843, sold at Christie's South Kensington in 1977 for £4,800 ($8,160). The dating of the daguerreotype is secure, since a woodcut from it was published in August 1843 in the *Illustrated London News*. It may be the first photograph ever taken of the act of photography.

T.R. Williams. 'Still Life with Dead Game'. Stereoscopic daguerreotype, early 1850s. Note the artistic signature of the photographer on the cask.

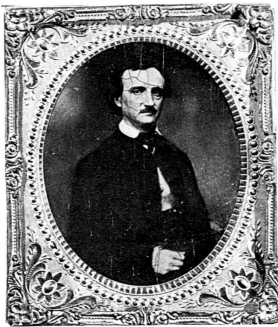

Edgar Allan Poe, a tintype copy of an apparently lost daguerreotype, c.1860.

Girl with an open book, autochrome by an unidentified photographer, c.1910.

7 **Orotone:** again not really a special process, but worth knowing about in connection with the work of Edward Curtis, famous for his portraits of American Indians. Some of his best-known studies were reproduced by this process, in which an image was printed from a negative onto a glass plate, producing a positive which was then backed with gold and elaborately framed. The process was used by Curtis *circa* 1910, at the height of his popularity.

## POSITIVE-NEGATIVE PAPER PROCESSES

1 **Photogenic drawing:** the first of the negative-positive processes. Niepce started it all in 1822 by successfully transferring an engraving to a sensitized glass plate. Working independently, W.H. Fox Talbot, in England, proclaimed his first success in 1835, using writing paper sensitized with silver chloride, exposed to light until an image was visible, then fixed with a salt solution. Talbot placed objects on his sensitized paper—ferns and feathers and the like—which, when left for a half-hour or so, produced negative photograms (i.e. images made without a camera) which Talbot subsequently began to contact-print in order to produce paper positives. Eighty years later photographers such as Laszlo Moholy-Nagy and Man Ray used essentially the same technique to make their photograms; Ray called his 'Rayographs'.

2 **Calotype or Talbotype,** also called **salt print:** the logical extension of the photogenic drawing process, made possible by the discovery of the 'latent image'. Once Talbot had established that an image was present on his sensitized paper, though still invisible, he began to expose his paper negatives for much shorter periods, leaving chemical development to bring out the image. This meant that cameras could more readily be used; even portraiture became possible.

Negatives used for the calotype process were usually waxed to give them longer life, and by contrast with positive prints, which are notoriously subject to fading, surviving waxed paper negatives are usually in fine condition, with rich and strong, though reversed, tonalities. Calotype positives—'salt prints' as they are often called—are identifiable by their matt surface and a break-up of the fine detail of the image due to the juxtaposition of paper fibres and wax in the negative, and the paper fibres of the positive printing paper. Fine calotype specimens will usually be a rich sepia, sometimes with vaguely purple overtones. Faded examples, which are much more common, usually turn yellowish.

Talbot's calotype process never achieved the popularity of the daguerreotype, partly because of the evanescence of the prints, which were sometimes known to fade away entirely, and partly because of Talbot's attempt to exact a royalty from every calotype practitioner for the use of his process. He seems to have succeeded in imposing a royalty in England, but not in Scotland and, needless to say, not in Europe or America. In France Bayard's experiments seem to have been at least partly independent of Talbot's, and in America the Langenheim Brothers adopted the calotype process for some of their work. The fact remains,

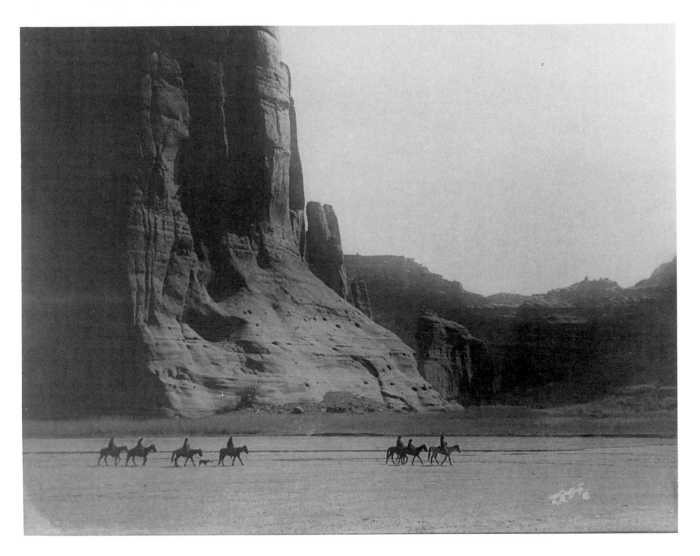

Edward S. Curtis. 'Cañon de Chellé', orotone, *c*.1910. This is a particularly fine example, with the photographer's signature in gold and in its original studio frame, and it sold at Sotheby's New York in 1983 for $9,750 (£6,094).

*Opposite*  W.H.F. Talbot. The Chess Players, salt print, *c*.1846. Courtesy Thackrey and Robertson.

however, that calotypes from the 1840s are rare, but a positive aspect of their rarity is that unidentified calotypes of British scenery can occasionally be traced to a specific photographer.

3 **Cyanotype** or **blueprint:** a photographic printing process based on iron salts, first demonstrated by the English astronomer Sir J.F.W. Herschel in 1840. The resulting prints are of a quite startling blue (Lee Witkin says a painter would call it 'Prussian blue'), and they are notable in being chemically perhaps the most stable of all early processes. The world's first photographically-illustrated book, Anna Atkins's *Photographs of British Algae* (1843) was subtitled 'Cyanotype Impressions', and the prints are as rich in their tonalities today as no doubt they were in 1843. In pre-Xerox days the cyanotype process was used to reproduce architects' drawings, and in recent years it has occasionally been used by photographers in combination with other processes.

4 **Wet collodion-albumen process:** though actually comprising two separate processes, these are often lumped together, since almost all photographers who produced wet collodion negatives made albumen prints from them. But that was not invariably so. Scott Archer's collodion process, invented in 1851, involved dissolving nitrocellulose in ether and alcohol—a heady mix for the unwary—coating a glass plate with the resulting mixture and exposing the plate while it was still wet. Early photographers who adopted Archer's process—which, though messy, produced superior negatives from much shorter exposures—continued producing old-style salt prints from their new glass negatives. But albumen printing was introduced in France by Louis Désiré Blanquart-Evrard in 1850, and soon printing paper, ready-coated with the appropriate salt-and-albumen solution, was available from photographic suppliers. It needed only an application of silver nitrate by the photographer before printing. The most important subsequent sophistication of the albumen printing process involved toning with gold chloride, which produced the characteristic sepia colour to be seen in most of the best examples of the genre.

Distinguishing the various permutations of these early paper printing processes is not always easy. There is no doubt that photographers of different times and places made salt prints from wet collodion negatives and albumen prints from waxed-paper negatives. In a few cases both salt and albumen prints from the same negative survive, and, to complicate matters further, there are even instances where photographers seem to have coated already made salt prints with a layer of albumen in an effort to inhibit fading. These 'albumenized salt prints' can usually be dated to the 1850s.

Don't worry too much about all this. You should, with practice, be able to tell a print taken from a waxed-paper negative from a print taken from a wet-collodion glass negative: look for the slight indistinctness ('softness' is as good a term as any) and signs of paper fibre in the image printed from a paper negative. Where a paper negative has been used, and there is an albumen coating to the print, the work can safely be placed in the 1850s. A salt print from a wet-collodion glass negative—

Photographers at work, 1853.

not too uncommon in early 1850s England, where photographers had learned about their countryman's invention but not of the Frenchman's—can usually be dated before 1860.

5 **Carte-de-visite photography:** an adaptation of the wet-collodion process to commercial photography. The technique was first promoted by André (or Adolphe) Disderi in 1854, and involved a special camera with multiple lenses and a sliding plate holder. With this equipment eight, or even ten, poses could be produced on the same plate in much the same way that commercial daguerreotypists produced fraction-of-a-plate portraits. Within a few years cartes-de-visite had become the rage. So called because of their size and their promotion as a uniquely personalized calling card, cartes-de-visite were always about $3\frac{1}{2} \times 2\frac{1}{4}$ in., mounted on a $4 \times 2\frac{1}{2}$ in. card; album windows for them could therefore be standardized. The number of poses and duplicate prints that could be made for a small sum enabled sitters to exchange their portraits with family and friends, and albums could be given a grander touch with the purchase of 'cartes' of royalty and other celebrities, available for a shilling or less at local stationers.

During the mid-1860s the larger cabinet portrait (about $5\frac{1}{2} \times 4$ in., mounted on a $6\frac{1}{2} \times 4\frac{1}{2}$ in. card) began to compete with, finally to

A characteristic carte-de-visite photographer's logo, usually found on the reverse of commercial cartes. I suspect that well-known portraits mounted on plain card may have been the work of 'pirates'. Often the dates of international exhibitions, prizes won, etc., included in these logos can be useful in dating the portraits on the other side of the card.

supplant, the carte-de-visite, and by the late 1870s a large variety of 'imperial' and 'boudoir' sizes began to be produced. As a genre the small mounted portrait remained popular until the First World War.

6  **Stereoscopy**: included among the paper processes due to the enormous popularity of the stereo card, but in fact spanning the entire range of processes from daguerreotype onwards. A brief history of the stereoscopic craze is given in Chapter 3. Processes found in stereoscopic format include daguerreotypes, ambrotypes, and the ubiquitous albumen-printed stereo card. (I have never seen a stereoscopic tintype.) In addition to the usual processes found in stereo, there exist 'tissue' stereo cards, with the image printed on thin translucent paper, sometimes backed with tinting to give a somewhat crude 'colour' effect. These tissue cards are meant to be viewed with light transmitted through the image, and they will not work in the large table viewers of the 1850s and early 1860s. Another stereoscopic oddity is the casket portrait, in which a prism mounted with a single portrait causes it to be reflected at an angle, creating a stereo effect.

7  **Carbon** or **autotype print**, also **bromoil** and **gum bichromate**: a variety of different processes collectively known as 'pigment' printing. The basis of all these processes was Fox Talbot's discovery that gelatine sensitized with potassium bichromate hardens on exposure to light and becomes insoluble in water. When a pigment was added to the gelatine the unexposed parts could be washed away, leaving a distinct image.

An American 'memento mori', cabinet portrait, *c.*1885.

The first successful process involving pigmentation with carbon was the invention of the Englishman Joseph Swan. It began to be used around 1865, and a few of Julia Margaret Cameron's photographs were printed by this process, though not, I believe, by her. By the mid-1870s carbon prints were frequently in evidence, and much was made of their 'permanence'—a claim that the passage of time has substantiated. Photographers at the end of the nineteenth century, notably the English 'Linked Ring' and the American and French pictorialists, used pigment processes to achieve a 'fine art' effect, carbon being thought comparable with charcoal drawing. Gum-bichromate (involving watercolour dyes suspended in gum arabic) and bromoil (oil pigments absorbed into silvered gelatine) were similarly compared with watercolour and oil painting. Robert Demachy was perhaps the prime exponent of the gum-bichromate process at the turn of the century; bromoils were made by several of the American Photo-Secessionists.

8 **Silver** or **gelatine-silver negatives and prints:** the processes that revolutionized photography. Beginning in 1871 with the publication of the Englishman R. Maddox's paper on a new photographic emulsion comprising gelatine and bromide of silver, various inventors tried to produce usable dry plates for cameras, the wooden interiors of which had previously been subject to rot by volatile wet collodion mixtures. In the 1880s the dry gelatine mixture was adopted by the American George Eastman to celluloid roll film, and by about 1890 the gelatine-silver chemistry became the basis of commercial printing-out paper, which was faster, cheaper and more permanent than the old style albumen paper. Silver prints, as their chemistry implies, substitute grey tonalities for the sepia of albumen prints, though of course silver prints could be toned, as demonstrated by Edward Curtis's sepia-toned studies of American Indians, and much other American and European work at the turn of the century. Old silver prints will sometimes show a metallic discoloration, usually slight and mostly confined to the edges of the print. Occasionally silver prints were treated with carbon tissue to give them greater depth and permanence; these are called 'carbro' prints.

9 **Platinum** or **platinotype print:** perhaps the most elegant—and the most expensive—of photographic printing processes. It was patented by the Englishman William Willis in 1873 and was catapulted to prominence as a medium for artistic photography by Peter Henry Emerson in 1886, when he used the process for the prints in *Life and Landscape on the Norfolk Broads*. The process employs iron salts which, during development, cause platinum precipitates to lie directly on the printing paper rather than in an albumen or gelatine emulsion. This gives the finished print a matt, almost calotypic, effect whereby the image appears to be embedded in the fibres of the paper. This effect, combined with the almost infinite range of greys obtainable from the process, creates an exquisite impression unique among photographic techniques. The process was popular with the Linked Ring and the Photo-Secession—some practitioners toned their platinum prints, usually to sepia—but successive price rises for raw platinum during the First World War drove the cost of platinum paper beyond most photo-

Charles Puyo. Nude on Beach, bromoil print, 1924. Even in a monochrome reproduction, as here, the powerful, impressionistic effect of the bromoil printing is evident.

graphers' reach, and the Platinotype Company ceased manufacturing its paper in 1937. In recent years photographers like Irving Penn and Robert Mapplethorpe have revived the technique, with striking effects.

10 **Colour processes:** too numerous, complicated, and in any case beyond my technical ability to describe fully, but it is worth mentioning Frederick Ives of Philadelphia, who produced a way of making negatives with three different-coloured filters, and, of course, the Lumière Brothers, who patented the autochrome process and whose firm continued independent experiments with colour processes up to the beginning of the Second World War. Modern colour techniques, pioneered by Kodak, also involve three filters, or rather three layers of emulsion, each sensitized to a different third of the colour spectrum. The first practical colour film was marketed in 1935, becoming more widely available in the late 1940s. A few intrepid technicians, such as Paul Outerbridge, made colour carbro prints in the 1930s, using three separate gelatine-silver negatives and three sets of carbon tissues in the primary colours. These colour carbro prints, unlike most colour work,

have much the same permanence as modern dye-transfer prints, which use three separately-filtered negatives and three-part printing with dye-impregnated gelatins. Recent inventions, such as Kodak's Cibachrome, have finally begun to solve the problem of the impermanence of colour images, but all colour photographs, whatever their process, are subject to considerable fading if exposed to strong light.

Joseph Peronnet, photographic chemist. This portrait was taken at the Lumière laboratories in Lyons in the 1930s as part of Peronnet's experiments in developing a commercial colour process from potato dyes. War intervened, and Kodak processes later came to dominate the market. Courtesy of a French private collection.

## PHOTOGRAPHIC PRINTING PROCESSES

1 **Engraving** and **lithography** from photographs: not, of course, photographic printing processes at all, but worth remembering since in the first couple of decades of photography publishers were wont to capitalize on the popularity, or notoriety, of the new medium. One of the first publications of this sort was N.P. Lerebours' *Excursions Daguerriennes*, 1840, containing steel engravings copied from daguerreotypes, some taken as far afield as Moscow and Egypt. Some of the original daguerreotypes were later purchased by Queen Victoria and Prince Albert. The Frenchman Hippolyte Fizeau attempted to etch and print from daguerreotype plates themselves, but only a few impressions could be obtained before the plate went 'soft'. Another abortive early process was called 'photoxylography', in which a photograph was produced on a chemically-sensitized woodblock and then carved by a woodcutter. The process was used in the 27 April 1839 *Magazine of Science*. Photolithography, developed in France by Alphonse Poitevin, was more successful, involving a stone plate which, once sensitized to light, attracted or repelled ink according to the amount of light received. A rare example of this is John Pouncy's *Dorsetshire Photographically Illustrated*, 1857. But the results of the process did not look very like photographs, and it was left to other processes to make the technical advances enabling low-cost mass production of photographic images.

2 **Photogalvanograph** and **photoglyph:** two quite different processes used only in the 1850s. The Austrian Paul Pretsch invented an engraving process whereby a sensitized metal plate was etched proportionally to the amount of light received—darker areas were etched more deeply and so received more ink. This photogalvanograph process, a forerunner of photogravure, was very expensive, and the only examples likely to be seen are the handsome plates from the 1856 publication *Photographic Art Treasures*, with work by Fenton, Lake Price and others. Photoglyphy was an invention of Fox Talbot's, patented in 1852, and involved coating a printing plate with chromated gelatine which hardened when exposed to light and could then be etched with metal chloride. Later sophistications of the process used a screen of muslin which broke up the photographic image into dots of ink. This process was not a commercial success, but examples appeared in photographic journals in 1858 and 1859, and Talbot's chromated gelatine reaction became the basis of later, more successful, photomechanical processes.

Lake Price. 'Don Quixote in his Study',
photogalvanograph, 1856.

3 **Collotype**: a high-quality, fine-grain printing process, in which a
coat of bichromated gelatine is applied to glass, dried, then exposed to a
photographic image which causes the gelatine surface to harden in pro-
portion to the amount of light received. Poitevin, the inventor of photo-
lithography, pioneered the collotype process, but it achieved commercial
success only with modifications by Josef Albert. Early collotype processes
were sometimes called 'phototype', 'albertype', or, as with Rejlander's
illustrations for Darwin's *Expressions of the Emotions in Man and
Animals*, 1872, 'heliotype'. Expertly produced collotypes can be hard to
distinguish from original photographs, but most examples, such as the
Rejlander plates and those from Muybridge's *Animal Locomotion*, have a
slightly greasy appearance due to the kind of ink used, and under a mag-
nifying glass the faint mesh pattern of the plate can usually be seen.

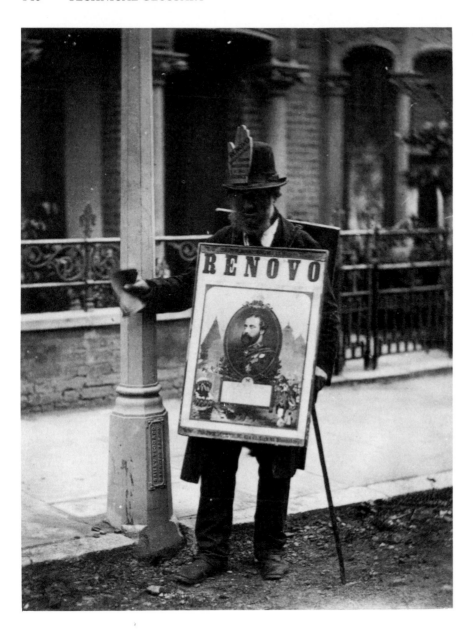

John Thomson and Adolphe Smith. A scene from *Street Life in London,* 1878, Woodburytype.

4 **Woodburytype** or (French) **photoglyptie:** probably the first commercially successful photomechanical printing process, invented by the Englishman Walter Woodbury in 1865 and popular throughout the 1870s. A negative etched mould was made into which pigmented gelatine was poured. When paper was pressed against the gelatine, then peeled away, the positive image was revealed, the thickest areas of the gelatine becoming the darkest areas of the print. It is all but impossible to tell a Woodburytype print from a carbon photograph; the only hope of distinguishing the Woodburytype is to spot the tiny flecks of pigment in the light areas of the image, or the uneven reflection of the print surface

resulting from the higher levels of gelatine in the dark areas. John Thomson's *Street Life in London*, 1878, is perhaps the best-known book to have been illustrated with Woodburytypes.

5 **Photogravure:** perhaps the finest of all photomechanical processes, producing prints comparable in their refinement with the best of other graphic media. The process, invented by the Czechoslovak Karl Klíc in 1879, involved chemically etching a negative image into a copper plate, so that the darkest tones were etched deepest and held the most ink. P.H. Emerson's *Pictures of East Anglian Life*, 1888, and other books of the late nineteenth century adopted this process and it was used in many artistic photography journals of the period, most notably Stieglitz' *Camera Work*. Several fine photographic printers of the present day have revived the technique.

6 **Half-tone:** the now-ubiquitous screen process which converts a photographic image into a series of dots, with the dots farther apart in the light areas of the image and close together in the dark areas. Frederick Ives's patent technique, introduced in the United States in 1878, was probably the first commercially-successful method. It revolutionized the printing of illustrations by allowing blocks to be produced which could be set up and inked alongside ordinary printing type. A half-tone block can be printed more than once on a single sheet of paper, which allows a higher standard and more than one colour in what is called 'duotone' printing. Perhaps the finest realization of the half-tone process is Richard Benson's magnificent series of plates illustrating the Gilman Collection, a few of which are reproduced in this book.

# Notes

1 *Rarity, Taste and Technique*

1 Pierre Apraxine, *Photographs from the Collection of the Gilman Paper Company. With Plates by Richard Benson* (Yulee, Florida, 1985), p. 19.

2 'Roger Fenton', in *Christie's Review of the Season 1978*, edited by John Herbert (London, 1978), p. 480.

3 J.B. Priestley in *Delight*, quoted in Helmut Gernsheim, *Julia Margaret Cameron* (London, 1975), pp. 173-74.

4 Julia Margaret Cameron, 'Annals of My Glass House' (1874), quoted in Helmut Gernsheim, *Julia Margaret Cameron* (London, 1975), p. 180.

5 Ian Jeffrey, *Photography. A Concise History* (New York, 1981).

6 Ibid., p. 27.

7 Sam Wagstaff, *A Book of Photographs from the Collection of Sam Wagstaff* (New York, 1978), p. 2.

2 *Collectors and Collecting*

1 For more on these amateur groups see the exhibition catalogue *A Vision Exchanged*, by Carolyn Bloore and Grace Seiberling, Victoria and Albert Museum, 1985. Haworth-Booth offers a useful footnote on Prince Albert and another voracious early collector, Sir Thomas Phillipps, in 'The Dawning of an Age. Chauncy Hare Townshend: Eyewitness', *The Golden Age of British Photography*, Victoria and Albert Museum, 1984: 'Prince Albert's collection has not survived in its entirety. A study of his collecting activities in in preparation.... The albums he assembled in the 1850s are available for study on the microfilm Royal Archives at Windsor Castle.... Some evidence survives of the enthusiasm for photography of the bibliophile Sir Thomas Phillipps, but the extent of his collection is as yet unestablished.' (p.21, note)

2 Haworth-Booth, op.cit., p. 15.

3 Ibid.

4 Haworth-Booth, 'A Connoisseur of the Art of Photography in the 1850s: The Revd. C.H. Townshend', in *New Mexico Studies in the Fine Arts* (Albuquerque, 1984), p. 9.

5 Quoted in Haworth-Booth, 'Dawning of an Age', op. cit., p. 17.

6 Haworth-Booth, 'A Connoisseur of the Art of Photography', op. cit., pp. 7-8.

7 Charles Baudelaire, *Salon de 1859*, quoted in Jean-Luc Daval, *Photography History of an Art*, translated by R.F.M. Dexter (Geneva, 1982), p. 83.

8 André Jammes, in 'French Primitive Photography', *Aperture*, Vol. XV, No. 1, Spring 1970, unpaginated.

9 Baudelaire, *Salon de 1859*, quoted in Aaron Scharf, *Art and Photography* (Harmondsworth, 1974), p. 146.

10 John Pultz, 'Collectors of Photography', in *A Personal View. Photography in the Collection of Paul F. Walter* (New York, Museum of Modern Art, 1985), p. 13. Most of the statistics concerning this period in photography collecting are cited from Pultz' article.

11 Ibid., p. 14.

12 Stieglitz, quoted by Gene Thornton in the New York *Times*, 9 March 1975. Thornton went on to decry the new merchandizing approach to photography, exemplified in a recent Sotheby Parke Bernet auction, which, said Thornton, would have made Stieglitz 'cringe'.

13 Quoted in Pultz, op. cit., p. 16.

14 Gerard Lèvy, interview with the author in Paris, June 1985. All quotations from M. Lèvy in this book refer to this interview and are not separately footnoted.

15 André and Marie-Thérèse Jammes, *Niepce to Atget. The First Century of Photography. From the Collection of André Jammes* (Chicago, The Art Institute of Chicago, 1977), p. 10.

16 Pultz, op. cit., p. 19.

17 Ibid.

18 Ibid., p. 20.

19 Sam Wagstaff, interview with the author, July 1985. All quotations from Mr Wagstaff not otherwise attributed are from this interview.

20 Headline in the *Washington Post*, 3 February 1978.

21 Quoted in Pultz, op. cit., p. 21.

22 Apraxine, op. cit., p. 16.

23 Ibid., pp. 16-21.

24 Ibid., p. 21.

25 Los Angeles *Times*, Part VI, 19 June 1984.

26 *International Herald Tribune*, 8-9 September 1984.

27 Ibid.

### 3  Areas of Specialization

1 Jeffrey, op. cit., p. 14.

2 Talbot, quoted in Jeffrey, ibid., p. 12.

3 Harry Lunn, interview with the author in Paris, June 1985. All subsequent quotations from Mr Lunn not otherwise attributed are from this interview.

4 Cecil Beaton, *British Photographers* (London, 1944), p. 14.

5 Jeffrey, op. cit., p. 38.

6 D.P. in *Once a Week*, quoted in *'From Today Painting is Dead'. The Beginnings of Photography* (London, Victoria and Albert Museum, 1972), p. 33.

### 4  Modern Photography

1 Roland Barthes, *Camera Lucida  Reflections on Photography*, translated by Richard Howard (New York, 1981), pp. 17-18.

2 Tennyson Schad, 'Shooting from the Hip' in *How to Make your Money make Money*, edited by Arthur Levitt, Jr. (New York, 1981), p. 229.

3 Ibid., p. 231.

4 Apraxine, op. cit., p. 16.

5 Quoted by Peter Turner in *Personal Choice. A Celebration of Twentieth Century Photographs* (London, 1983), p. 122.

6 Susan Sontag, *On Photography* (Harmondsworth, 1980), p. 15.

### 5  Buying and Selling

1 Lee D. Witkin and Barbara London, *The Photograph Collector's Guide* (Boston, 1979), p. 4.

2 Huon Mallalieu, *How to Buy Pictures* (Oxford, 1984), p. 46.

3 Ibid, p. 38.

4 Schad, op. cit., p. 240.

### 6  Collecting Pitfalls

1 London *Sunday Times*, 2 November 1980.

2 London *Times*, 6 November 1980.

3 Ibid.

4 London *Daily Telegraph*, 29 October 1980.

5 *The British Journal of Photography*, Vol. 127, No. 6281, 12 December 1980, p. 1230.

6 All quotations in this paragraph are from the London *Times*, 7 May 1981.

7 Isabelle Anscombe, 'Daylight Robbery? Exposing the Shady Side of the Calotype.' *Connoisseur*, Vol. 207, No. 831, May 1981, p. 49.

8 Quoted in Bonnie Barrett Stretch, 'Photo Intensification', *American Photographer*, Vol. XV, No. 1, July 1985, p. 24.

9 Ibid.

### 7  Looking after Photographs

1 Mary-Anne Morris, interview with the author in London, October 1985.

# Sources of Supply:
# Some Useful Addresses

**AUCTIONEERS**

All auctioneers make a charge for their sale catalogues, but a letter of enquiry should bring you a schedule of sales. Most major New York and London sales are timed to take place during a single week, the New York sales normally in November and May, the London sales normally in October, March and June.

**Great Britain**

Christie's South Kensington
85 Old Brompton Road
London SW7 3LD

Phillips, Son & Neale
Blenstock House
7 Blenheim Street
New Bond Street
London W1Y 0AS

Sotheby's
34-5 New Bond Street
London W1A 2AA

**U.S.A.**

Butterfield & Butterfield
1244 Sutter Street
San Francisco
California 94109

California Book Auctions
358 Golden Gate Avenue
San Francisco
California 94102

Christie's East
219 East 67th Street
New York
New York 10021

Phillips, Son & Neale Inc.
406 East 79th Street
New York
New York 10021

Sotheby's
1334 York Avenue
New York
New York 10021

Swann Galleries
104 East 25th Street
New York
New York 10010

## GALLERIES AND PRIVATE DEALERS

The galleries and dealers listed below cover the entire spectrum, from the large metropolitan venue with regular exhibitions to the small, highly specialized dealer working from private premises. In every case an advance telephone call is advisable to determine, first, whether the gallery is open or the dealer available and, second, whether the dealership has material likely to interest you. This list is not exhaustive, and though many dealers on it are friends of the author many others he has never met; inclusion or exclusion implies neither recommendation nor censure.

**Great Britain**

Robert Hershkowitz
94 Queen's Gate
London SW7

Ken and Jenny Jacobson
Southcotts
Petches Bridge
Great Bardfield
Near Braintree
Essex CM7 4QN

N.W. Lott and H.J. Gerrish Ltd.
Masons Yard
Duke Street
London SW1

The Photographers' Gallery
5 & 8 Great Newport Street
London WC2 7HY

Vintage Images and Cameras
256 Kirkdale
London SE 26

Beryl Vosburgh
Jubilee
Camden Passage
London N1

Christopher Wood
15 Motcomb Street
London SW1

**France**

Gerard Lèvy
17 rue de Beaune
75007 Paris

Galerie Octant
5 Rue du Marché St-Honoré
75001 Paris

Galerie Texbraun
12 rue Mazarine
75006 Paris

Galerie Zabriskie
37 rue Quincampoix
75004 Paris

**West Germany**

PPS. Galerie F.C. Gundlach
Feldstr./Hochaus 1
2000 Hamburg

Galerie Rudolf Kicken
Albertus Strasse 1
D-5000 Cologne

**Switzerland**

Zur Stockeregg
Stockerstrasse 33
8022 Zurich

**U.S.A.**

G.H. Dalsheimer Gallery
519 North Charles Street
Baltimore
Maryland 21201

Fraenkel Gallery
55 Grant Avenue
San Francisco
California 94108

Alan Frumkin Gallery Inc.
1306 Byron Street
Chicago
Illinois 60613

A Gallery for Fine Photography
5423 Magazine Street
New Orleans
Louisiana 70115

Ursula Gropper Associates
10 Laurel Lane
Sausalito
California 94965

The Halsted Gallery Inc.
560 North Woodward
Birmingham
Michigan 48011

Alan Klotz
Photocollect
740 West End Avenue
New York
New York 10025

Robert Koch Inc.
P.O. Box 5249
Berkeley
California 94705

Hans P. Kraus, Jr.
238 East 74th Street
New York
New York 10021

Janet Lehr Inc.
P.O. Box 617
New York
New York 10028

Light Gallery
724 Fifth Avenue
New York
New York 10019

Robert Miller Gallery/Howard Read III
724 Fifth Avenue
New York
New York 10019

Russell Norton
P.O. Box 1070
New Haven
Connecticut 06504

Pace/Macgill Gallery
11 East 57th Street
New York
New York 10022

Prakapas Gallery
19 East 71st Street
New York
New York 10021

Rinhart Galleries Inc.
Upper Grey
Colebrook
Connecticut 06021

Sander Gallery Inc.
51 Greene Street
New York
New York 10013

William Schaeffer
300 West 23rd Street
New York
New York 10011

Staley-Wise
177 Prince Street
New York
New York 10012

Thackrey and Robertson
2266 Union Street
San Francisco
California 94123

Weston Gallery
Box 655
Carmel
California 93921

Stephen White Gallery
Suite 105
211 South Beverly Drive
Beverly Hills
California 90212

The Witkin Gallery Inc.
415 West Broadway
New York
New York 10012

Charles B. Wood III Inc.
South Woodstock
Connecticut 06267

Daniel Wolf Inc.
30 West 57th Street
New York
New York 10019

Courtia Jay Worth
Box 911
Springtown Road
Tilson
New York 12486

# Further Reading

The only essential periodical for collectors of photographs is called, not surprisingly, *The Photographic Collector*. It is published quarterly and subscriptions for Britain may be sent to The Bishopsgate Press, 21 New Street, London EC2M 4UN, or in North America to Russell Norton, P.O. Box 1070, New Haven, CT 06504.

Suggesting a course of reading for photography collectors is a daunting task, as so much is now available. I now consider the essential history of the medium to be Ian Jeffrey's *Photography. A Concise History* (New York, 1981), but this ought to be supplemented with the revised edition of Beaumont Newhall's *History of Photography* (New York, 1982) and, particularly for technical developments, Helmut Gernsheim's *The Origins of Photography* (London, 1982). Another useful book for collectors concentrating on the early years of the medium is Brian Coe and Mark Haworth-Booth's *Guide to Early Photographic Processes* (London, 1983). Lee Witkin and Barbara London's *The Photograph Collector's Guide* (New York, 1979) is enormously useful in providing directories of known photographers and their work, from daguerreotypists onwards. Roland Barthes's *Camera Obscura* (New York, 1981) is the only book I have read that really seems to me to grapple with the philosophical problems posed by photography; I find Susan Sontag's *On Photography* (Harmondsworth, 1980) eminently quotable, but often glib by comparison.

Other surveys include:

Turner Browne and Elaine Partnow, *Macmillan Biographical Encyclopedia of Photographic Artists and Innovators* (New York, 1983)

Jean-Luc Daval, *Photography. History of an Art* (New York, 1982)

Rainer Fabian and Hans-Christian Adam, *Masters of Early Travel Photography* (London, 1983)

Helmut Gernsheim, *Incunabula of British Photographic Literature 1839-1875* (London, 1984)

Lucien Goldschmidt and Weston Naef, *The Truthful Lens: A Survey of Photographically-Illustrated Books 1844-1914* (New York, 1980)

Jonathan Green (ed.), *Camera Work. A Critical Anthology* (New York, 1973)

Mark Haworth-Booth (ed.), *The Golden Age of British Photography* (New York, 1984)

André Jammes and Eugenia Parry Janis, *The Art of the French Calotype* (Princeton, 1983)

André Jammes and Robert Sobieszek, *French Primitive Photography* (New York, 1969)

Weston Naef, *The Collection of Alfred Stieglitz* (New York, 1978)

Beaumont Newhall, *The Daguerreotype in America* (New York, 1976)

Naomi Rosenblume, *World History of Photography* (New York, 1984)

John Szarkowski, *Looking at Photographs* (New York, 1973)

John Szarkowski, *The Photographer's Eye* (New York, 1966)

Robert Taft, *Photography and the American Scene* (New York, 1964)

George Walsh, *et al., Contemporary Photographers* (London, 1982)

William Welling, *Photography in America: The Formative Years, 1839-1900* (New York, 1978)

Most significant photographers have by now had monographs published about them. These vary in usefulness and can almost without exception be traced at a library or bookshop under the photographers' names. I have not, therefore, attempted to list them. More difficult to obtain nowadays are some of the seminal exhibition catalogues which in some cases still contain information unavailable elsewhere. If you can find them, I strongly recommend the following:

*A Book of Photographs from the Collection of Sam Wagstaff,* 1978

*'From Today Painting is Dead.' The Beginnings of Photography.* Victoria and Albert Museum, London, 1972

*Images of Italy. Photography in the Nineteenth Century,* by Wendy M. Watson. Mount Holyoke College, 1980

*Niepce to Atget. The First Century of Photography. From the Collection of André Jammes.* The Art Institute of Chicago, 1978

*Personal Choice. A Celebration of Twentieth Century Photographs.* Victoria and Albert Museum, London, 1983

*A Personal View. Photography in the Collection of Paul F. Walter.* Museum of Modern Art, New York, 1985

*Une Invention du XIX^e Siècle. Expression et Technique. La Photographie.* Bibliothèque Nationale, Paris, 1976

*A Vision Exchanged. Amateurs & Photography in Mid-Victorian England,* by Carolyn Bloore and Grace Sieberling. Victoria and Albert Museum, London, 1985

# Index